Universe Series on Women Artists

Suzanne Valadon

Universe Series on Women Artists

Suzanne Valadon

Thérèse Diamand Rosinsky

Universe

On the front cover:

*Auto-Portrait, 1924, oil on canvas,
15⅝ x 19⅝", Collection Paul Pétridès,
Paris, P 299*

First published in the United States of America in 1994
by UNIVERSE PUBLISHING
300 Park Avenue South
New York, NY 10010

©1994 Universe Publishing

Designed by Christina Bliss, Jolie Muller, and Tad Beck

94 95 96 97 98 99 / 10 9 8 7 6 5 4 3 2 1

Printed in Hong Kong

Library of Congress Cataloging-in-Publication Data

©Rosinsky, Thérèse Diamand.
 Suzanne Valadon / Thérèse Diamand Rosinsky.
 p. cm.—(Universe series on women artists)
 Includes bibliographical references and index.
 ISBN 0-87663-777-2
 1. Valadon, Suzanne, 1865–1938—Criticism and interpretation.
 I. Title. II. Series.
ND553. V3R67 1993
759.4—dc20 91-43885
 CIP

CONTENTS

TO MY PARENTS

ACKNOWLEDGEMENTS

I would like to express my gratitude to my friend Anne Lesser Abeles, professor of Art History at Long Island University, for her constant and invaluable assistance during the writing of this manuscript. I am greatly indebted to the following professors: Jane Schuyler of York College, whose constructive guidance never faltered, and Linda Nochlin of the Institute of Fine Arts for her patient and enlightened advice on my dissertation on Suzanne Valadon, and most particularly Diane Kelder of the City University of New York, for her generous attention to this manuscript and her enlightening suggestions. Charlet Davenport shared enthusiastically her perceptive insights on the works of Valadon.

My research in Paris was greatly helped by the kindness of the staff of the Bibliothèque du Musée d'Orsay and the generous assistance of Messody Zrihen and Nathalie Schoeller, documentalists at the Archives of the Musée National d'Art Moderne, CNAC Georges Pompidou. I would like to express my thanks to the Galerie Gilbert et Paul Pétridès and its director, Jeannette Anderfuhren. My infinite gratitude goes to Geneviève Barrez, who so selflessly opened her files to me and whose friendship honors me.

Working with the staff of Universe was a great pleasure. I was constantly encouraged by my publisher Adele Ursone's constructive suggestions and her unfailing support, as well as by Ellie Eisenstat's cheerful help. I also wish to thank Joan Horgan.

I greatly appreciate my son Alan Rosinsky's help in selecting and printing many documents, and Evelyne Amon's expert advice. Their faith in this project is most important to me.

INTRODUCTION

Reality is infinitely greater than any story,
any fable, any divinity, any surreality.

—ANTONIN ARTAUD, 1915

I n 1894, an unknown woman named
Suzanne Valadon exhibited five draw-
ings at the Salon de la Société Nationale
des Beaux Arts in Paris, the most prestigious
and exclusive art show of the time. Her pres-
ence there among celebrated contemporary
artists was an unprecedented and unex-
plainable event, since Valadon lacked the most
basic elements of success for entering an offi-
cial exhibition.

Being a woman, she belonged to a minority
whose art was seldom taken seriously. Self-
taught, she did not have long years of practice
with an established Beaux-Arts teacher whose
sponsorship would command an invitation to the
Salon. The works she exhibited—drawings of

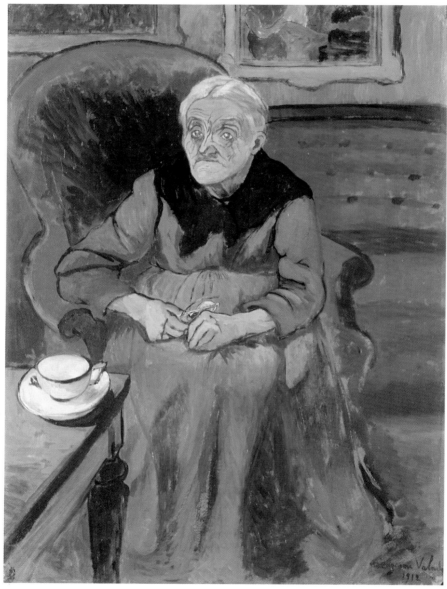

FIG. 1 PORTRAIT OF THE ARTIST'S MOTHER, *1883, CONTÉ CRAYON AND PENCIL, 13¾ x 11½", MUSÉE NATIONAL D'ART MODERNE, CNAC GEORGES POMPIDOU, PARIS, D 4*

scrawny children tended by a worn-out old woman—looked "unfeminine" as well as unappealing. Hers was a lower-class social background that had never produced a woman artist. Worst of all, because of a rigidly compartmentalized hierarchy, Valadon's ongoing work as a model should have prevented her from being recognized as a professional artist. These two careers were viewed as irreconcilable, even during the late nineteenth century. Therefore, her presence at the Nationale could only be seen as a "fluke," and her art as doomed to failure.

And yet, among such women artists of her time as Mary Cassatt, Berthe Morisot, and Marie Laurencin, Suzanne Valadon was the only one whose success was almost instant. As early as 1894, when she was only twenty-nine, Degas had purchased her drawings and, in 1897, the dealer Vollard had given her a first show. Not only did Valadon succeed in establishing herself as a professional artist but she did so while maintaining a personal style. Always remaining outside the realms of contemporary art movements, she imparted to some of her subject matter such bold and novel treatment that she broke with centuries-old traditions.

In order to understand and appreciate her work, one must place it within the context of

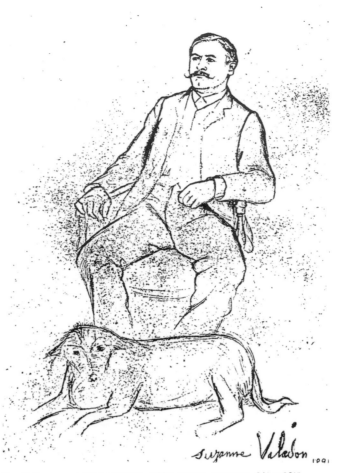

FIG. 2 PORTRAIT OF PAUL MOUSIS, *1894, PENCIL ON PAPER, 9⅛ X 6⅞",* MUSÉE NATIONAL D'ART MODERNE, CNAC GEORGES POMPIDOU, PARIS

French nineteenth-century art, where it is unique. The illegitimate daughter of an illiterate charwoman and herself a self-taught painter, she would become a well-known artist. A hard-working Montmartre model, she ultimate-

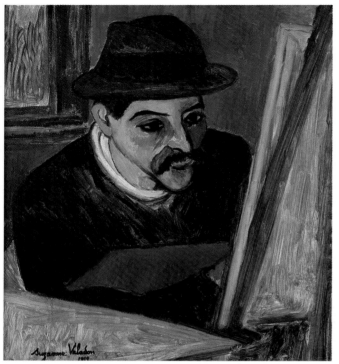

FIG. 3 MAURICE UTRILLO AT HIS EASEL, *1919, OIL ON CANVAS, 18 ⅞ X 17 ¾",*
MUSÉE D'ART MODERNE DE LA VILLE DE PARIS, P 145

about a theoretical allegiance to some given movement but a desire to capture the life she saw around her. While Courbet humorously defined his realist approach by stating that he would have painted an angel had he seen one, Valadon could not even conceive of seeing, let alone painting, an angel. A member of a desperately needy lower working class, she rendered only the harsh but true images of her daily existence. Her works are based on her perceptions, and these perceptions were conditioned by two determining factors: her gender and her life in Montmartre.

Any reading of Valadon's art must start with her identity as a female model and the single mother, at the age of eighteen, of an illegitimate child, functioning in a male-dominated society ruled by a strict social and sexual code. Of equal importance is the fact that she grew up and spent her entire life in Bohemian Montmartre. There, a permanent contact with art allowed her to view its creation as a natural function stripped of any esoteric mystique.

Valadon's art and work are inseparable. While many artists escape the drudgery of their immediate existence by creating on their canvas a world of their own, she did the opposite. It was her daily life—the familiar faces of her family and friends, the gardens and landscapes of her neighborhood—that she retraced for her viewers. The scrawny children, the banality, and often

ly fulfilled her artistic vocation and established her own style without relying on the influence of Puvis de Chavannes, Renoir, and Toulouse-Lautrec, her patrons as well as her lovers. It was actually her uniqueness that marked Valadon as an outsider, so removed from the expected social and aesthetic norms that she could not be judged by the criteria applied to other women artists. Her art itself has resisted attempts to categorize it as either Realist, Fauvist, or Expressionist, and it can only be loosely tied to the School of Paris, a regional rather than stylistic designation.

Valadon's own concern, however, was not

vulgarity, of her intimates, the inexorable passage of time, clinically recorded in her self-portraits, are all objectively transcribed, without hope of pity or fear of judgment.

When Suzanne Valadon died at seventy-three, she left 478 paintings, 273 drawings, and 31 etchings. Her range of subject matter included nudes, portraits, landscapes, and still lifes. It is mostly in her representations of female nudes and children, and in her portraits, that she showed her most daring innovations and disrupted many of the existing conventions. There is no doubt about the greatness of her talent and the innovative quality of her art. But she also possessed an extraordinary nature that enabled her to turn into positive assets situations that would have presented insurmountable handicaps to a different artist. She combined the careers of model and painter—an alliance never successfully achieved before. It could have resulted in an unmanageable duality between the passivity of one and the creativity of the other. Instead, from her experience in posing she gained a new awareness of her body, used and seen as an object by male painters and viewers. This realization added a new dimension to her pictorial approach to female nudity that enabled her to purge it of its pre-existing sexual connotations. For the first time in centuries, women were no longer offered as subjects of lust to male spectators, and they were shown on their own.

Valadon's images of children stemmed from her own experience as a mother and her observations of her son and young neighbors. She broke with an iconographic code that traditionally placed children in a sheltered familial environment. Valadon exposed their physical awkwardness, their poor health, as well as their alienation and, often, their despair.

Her many portraits, done with complete

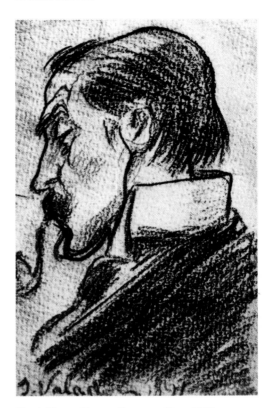

Fig. 4 Miguel Utrillo Smoking a Pipe, *1891, charcoal on paper, 6⅞ x 4⅜", private collection,* D 5

truthfulness, even when commissioned, reveal the clinical sharpness of observation seen in many of the portraits of Jacques-Louis David.

As a single parent, Suzanne Valadon had to provide for her son's needs as well as those of her mother, who looked after the child. She had to work full-time as a model and, in spite of her desire to become an artist, had neither the money, the time, nor the accessibility to private art instruction, that her contemporaries Berthe Morisot and Mary Cassatt possessed. Whatever Valadon knew about art was acquired through

her own personal efforts. Her resourcefulness enabled her to use her modeling career as an asset for the making of her art. By closely observing the techniques of those for whom she posed and painstakingly practicing alone, she was able to develop a mode of expression that is unmistakably her own.

For almost six decades, Suzanne Valadon went on drawing and painting in her own style, on her own terms. Aware of contemporary movements, she sailed through Impression-ism, Symbolism, Fauvism, and Cubism, only borrowing from them at the beginning of her career. Later on, she used them as reference, not as a bible.

While conscious of her artistic debt, she ultimately realized the value of her personal achievements: "I had great masters. I took the best of them, of their teachings, of their examples. I found myself, I made myself, and I said what I had to say."

BIOGRAPHICAL NOTES

Valadon said that she was born on June 6, 1867. Her actual birth date was September 23, 1865. As an artist she signed her works "Suzanne Valadon"; as a model, she was known as "Maria."[1] Her given name was Marie-Clementine. She pretended that she had been found, as an infant, on the steps of the Limoges Cathedral, and she introduced her real mother as the woman who had adopted her. She ignored the name of her father and never told her son, Maurice Utrillo, the identity of his own sire.

Confusion looms over Valadon's life. A lack of primary documents, an absence of correspondence or personal diaries, are aggravated by the erroneous writings of a press more concerned with Valadon's "sensational" impact than by the quality of her art. The long list of her famous lovers, her talented son's alcoholism, the youth of her second husband,[2] and their violent fights, earned those three the name "Forsaken Trio."

The quest for historical truth is further complicated by Valadon's mythomania. Her tendency to "mythologize" began early in her life as an escape from her bleak daily existence. She

invented stories that she told with variations to each listener. Her mystifications were often accepted candidly and, at times, recorded by biographers, all of whom seem to refer to a different Valadon.

Actually, she did not have to resort to fiction. Each facet of her life and fate is as colorful and often more unbelievable than any of the stories she manufactured herself.

She was born on September 23, 1865, at Bessines-sur-Gartempe, a small town near Limoges in central France. Her father was unknown. Her mother, Madeleine Valadon, was thirty-four, a sewing maid in a bourgeois household. She had been married to Leon Coulaud, a blacksmith with whom she had two daughters, Marie-Emilienne and Marie-Aline. Coulaud was arrested for forgery and condemned to hard labor in 1859. He died that same year.

Madeleine Valadon[3] was a sullen woman who never spoke about the man who impregnated her, but he is likely to have been one of the engineers who came temporarily to the region when a segment of the Paris-Toulouse railroad was built in early 1865.[4] Madeleine Valadon, already humiliated by her husband's imprisonment, could not bear the disgrace of her last child's illegitimacy. Shortly after Suzanne was born, Madeleine fled to Paris, leaving her older children in the care of relatives. The redesign of Paris directed by the baron Haussmann was still in progress, and many peasants fled the poverty of their villages in the hope of finding work in the capital.[5]

The demolition of the old neighborhoods, as well as the construction of new ones, provided jobs for skilled and unskilled laborers. Madeleine Valadon had hoped to find a position as a laundress or seamstress, but the competition was such that, in order to survive, she had to become a charwoman. She found a room on the boulevard Rochechouart, in Montmartre, at the time an inexpensive neighborhood. Perched at the top of a hill, the "Butte"[6] was still much of a rural commune, best known for its working mills, cheap rents, and the extraordinary number of artists who lived there. Madeleine was soon overwhelmed by her work and had to leave her daughter to the indifferent care of a "concierge." Around 1870, she sent the child to her oldest daughter, Marie-Emilienne, who had married a well-to-do man and was living in Nantes.[7] Suzanne Valadon's[8] stay in Nantes has not been mentioned in any of the biographies.[9] The child was sent back to her mother because of a "rotten disposition."[10] She was enrolled as a day student in the near-by convent, Saint Jean de Montmartre, run by the sisters of Saint Vincent de Paul. She stayed there until she was about eleven and learned to read, write, and do simple arithmetic. A frequent truant from school, she was relieved when she was removed from the convent in order to contribute to the family's finances. She was ill-fitted temperamentally to the discipline of a religious education. Her rare letters, containing spelling errors, are evidence of the brevity of her schooling.

She started, and soon abandoned, various jobs—groom in a stable, apprentice vendor in an open market. In his unfinished biography of Valadon, her husband, Utter, writes that she entered a garment sweatshop when she was about fourteen.[11] Although most of her biographers differ as to the nature of Valadon's early jobs, they unanimously agree on her lack of enthusiasm for any of them. It was not until 1880 that she fulfilled a child's dream by joining a circus.

Circuses were extraordinarily popular in France during the nineteenth century, and sev-

eral of them were permanent-
ly situated in Paris. There
were also numerous traveling
groups that pitched their tents
for a few days in various
cities. The frenzied activity of
the ring, its chronic tumult,
and the brassy music were a
source of fascination for
Valadon, whose ebullient na-
ture thrived in the frenetic
activities of the circus. She
never alluded to her early
childhood when she told the
story of her life. She would
start with enthusiastic but
varying accounts of her expe-
rience with the circus. The
nature of her work there is
problematic, since she pre-
tended to have been an acro-
bat, the Snake Woman, and an
equestrian, although her name
(perhaps changed) does not
appear in any of the programs
of the best-known establish-
ments.[12] But her circus career
was short-lived after she suf-
fered a serious injury in the
ring. She recovered, but lost
some of her agility. At fifteen,
regretfully, she had to look for
a new career.

As we know through vari-
ous accounts, Suzanne Valadon

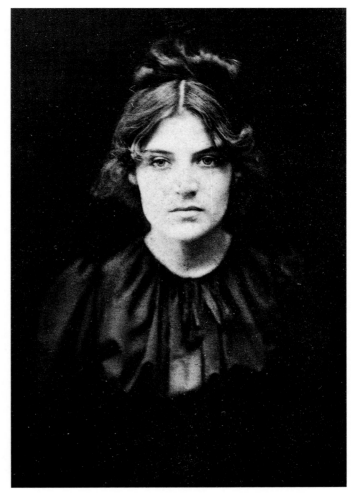

FIG. 1 SUZANNE VALADON AT TWENTY. COURTESY OF GALERIE GILBERT ET PAUL PÉTRIDÈS.

was attractive. Less than five feet tall, she had
a voluptuous figure and a beautiful face, with
bright blue eyes and the creamy complexion
loved by Renoir. These were assets that
became useful when she chose to be a model.

She undertook her new profession with the
passionate interest she had shown for the cir-
cus world. Hers was a long career, since she
was still posing in the nude at twenty-eight.

Marie-Clementine became Maria for her

patrons, who were numerous and included the traditional Puvis de Chavannes,[13] who recommended her to the Impressionist Renoir;[14] as well as the unconventional Toulouse-Lautrec.[15] These three artists became her lovers, according to an unspoken law that demanded that the model should also be sexually available to the artist.[16] Valadon posed for several other painters, such as the Italian Frederico Zandomeneghi (1841–1917) and Giuseppe de Nittis (1846–1884), among others.[17]

Valadon had started to draw at eight, and persevered in spite of her mother's lack of understanding. Madeleine continued to work as a charwoman, but she had a drinking problem. Although she had never shown any affection for her daughter, the two women shared successive apartments throughout the older woman's life. An unplanned event took place in 1883 that gave Madeleine a new role in the Valadon household: she became a grandmother as well as a surrogate mother. On December 26, 1883, Suzanne gave birth to a son, later to be known as Maurice Utrillo. The child was illegitimate, as was his own mother. In 1891, when he was eight, he was acknowledged by the Spanish journalist, Miguel Utrillo, who had been one of Valadon's lovers in 1883.

A strong resemblance between Miguel Utrillo and Maurice appears in the portraits that Valadon did of both (fig. 3 and fig. 4 in Introduction). Furthermore, even though Miguel left France before Maurice's birth, he seems to have kept in touch with Valadon, who was able to move with her family from rue Cortot to a larger flat at 7 rue Tourlaque. Since she had to give up her modeling during the last months of her pregnancy, it is probable that the wealthy Miguel gave her financial assistance.

After the birth of her son, Valadon resumed her modeling and had a brief liaison with the musician Eric Satie. She had met a wealthy broker, Paul Mousis, who married her in 1896, thus ending the financial uncertainties that had plagued the Valadon family.

Valadon had continued drawing and started painting when she was fourteen, but she destroyed almost all of her early works. For guidance she observed the painters for whom she worked and continued to practice during her free moments. She counted Zandomeneghi among her neighbors on the rue Tourlaque. When the Italian saw her works, he introduced her to the sculptor Paul Albert Bartholomé (1848–1928), who perhaps sent her to his friend Degas. The latter was so impressed by her talent that he bought one of her first drawings. Valadon never modeled for Degas, who had the highest regard for her talent. He wrote her until his death to inquire about her "wicked and supple" drawings, which he collected.

When Valadon decided to show at the Salon de la Nationale des Beaux Arts, Bartholomé gave her a recommendation to the president of the Salon, Paul Helleu (1859–1927). Five of her drawings were exhibited.

From 1896 to 1909, Valadon led a pleasant life. Mousis had built a house in Pierrefitte, where Madeleine Valadon and Maurice Utrillo also lived. But he kept a studio for Valadon on the rue Cortot. Maurice Utrillo went to school in the country, where he was a mediocre student and soon showed signs of alcoholism. Mousis helped him to find work in the Credit Lyonnais bank in Paris for a short while but was distraught about the adolescent's drinking. On the advice of a Dr. Ellinger, Valadon started to teach painting to her son as a therapy. However, Utrillo did not stop drinking and had

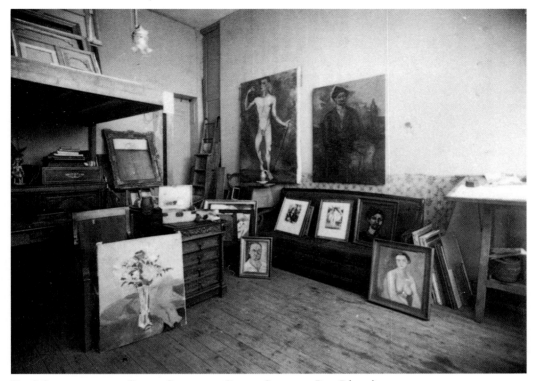

FIG. 2 STUDIO OF THE RUE CORTOT. COURTESY OF GALERIE GILBERT ET PAUL PÉTRIDÈS.

to be hospitalized in several institutions for most of his life.

Valadon pursued her art and started to sell her works to dealers, and in 1897, the celebrated Ambroise Vollard published several of her etchings.

By 1909, Valadon had been married for thirteen years. The respectable Paul Mousis was finding it increasingly more difficult to deal with his stepson's alcoholism and emotional problems. The unconventional Valadon started to find suburban life oppressive, and her husband's respectability unchallenging. In 1909, she met one of her son's contemporaries, the painter André Utter. Although he was twenty-one years younger than she, "an intense love story developed between the two."[18] She left Mousis, asked for a divorce and, followed by Utter, Maurice Utrillo, and her mother, went back to Montmartre. She rented a flat at 5 Impasse de Guelma, where new ateliers had just been built. Dufy, Braque, and Severini lived there. After a while,

she moved back to 12 rue Cortot, into a studio vacated by Emile Bernard.

Utter had a beneficial influence on Valadon. She was mostly drawing and etching at the time. "She was too afraid to paint," wrote Utter, who added, "It was at my contact and on my pleading that she started to paint."[19] Between 1909 and 1914, the outbreak of World War I, Valadon and Utter lived happily, despite their occasional loud quarrels. Valadon had a fiery temperament that "made life with her difficult," an assessment given by Marie-Emilienne's daughter, Marie Coca, who was very fond of her aunt.[20]

Soon the artist began to paint with an extraordinary energy. Several of her large compositions were done during this period. In 1911, her works were first shown by the enterprising dealer Clovis Sagot, and Maurice Utrillo was "discovered" by the writers Francis Jourdan and Octave Mirbeau.

The artists lived together, fought together, and painted together. They also traveled together. In 1912, the trio went to Brittany, to the Island of Ouessant, where Valadon painted several landscapes. The following year, they visited Corsica. Valadon did views of the countryside and of Corté and Belgodère. Most importantly, she started her ambitious *Casting of the Net*, and Utter posed in the nude in a bright mountainous background rising against the Mediterranean Sea.

Valadon first exhibited at the Salon d'Automne in 1909, and two years later at the Salon des Indépendants. Her works were shown in Munich in 1912, in a group show organized by Sagot. She was now regarded as a professional artist. In 1913, she exhibited in a group show at the Berthe Weil Gallery. The dealer became a close friend, and Valadon continued to show with her until 1928.

When the war with Germany broke out in 1914, Utter was drafted, and the couple married in August, before Utter joined his regiment in Belleville. Utrillo was also drafted but discharged. The four years of war were difficult for Valadon. She lived with her son and her mother until Madeleine died in 1915. Except for brief intervals, the artist had always stayed with Madeleine, who looked after her grandson. The latter's dipsomania was inexorably worsening. Bearing the burden of Utrillo's problems was a hard task for Valadon, who missed her young husband desperately. In 1917, when she learned that Utter had been wounded, she rushed to the military hospital of Meyzieux[21] where he was convalescing.

When the war ended in 1918, Utter came back safely to the rue Cortot. Valadon's artistic output had lessened during his absence, but upon his return she experienced a new energy. She worked intensely on portraits and still lifes. In 1919, she did a series of nudes posed by a mulatto girl.[22] She continued showing in the Salons d'Automne and Indépendants, as well as in private galleries.[23] Utrillo's fame and fortune were increasing under the skillful management of his stepfather. The family was experiencing a new prosperity, although Utter, a good painter himself, regretted having less time for his artistic career. But he felt that when "he became the head of the family, he assumed the responsibility of two terrible children deprived of any practical sense."[24] Valadon was extravagant with money, Utrillo's sole preoccupation was his next drink, and Utter became increasingly bitter about Utrillo's phenomenal success. Valadon was obsessively jealous, and the couple's quarrels multiplied. Utrillo spent much time in psychiatric institutions and in police stations, since he was frequently detained for his violent public scenes. The chasm between the artist and her husband

widened without affecting the quality and the fertility of Valadon's work.

In 1921, the artists vacationed in the beautiful Beaujolais country. The following year, they traveled to Brittany. In each site, Valadon spent much time painting the surrounding landscape. In spite of the time he spent managing Utrillo's sales, Utter still showed with his wife and stepson. In 1922, the "Forsaken Trio", as it was called by the press, exhibited in Limoges at the Dalpayrat gallery, and Robert Rey published the first monograph on Valadon. The following year, the three artists went to Ségalas, in the Basses Pyrénées, to visit the painter Georges Kars and his wife, one of Valadon's close friends. It was also the year when they bought the thirteenth-century castle of Saint Bernard. They were to share their time between the Montmartre studio and the castle until 1932.

Valadon's artistic popularity increased and her works sold well. Although she did not achieve Utrillo's fame, she felt no envy, only great pride in his "genius."

The sojourns at Saint Bernard did not heal the couple's increasing problems. Valadon's jealousy had become justified, as Utter did little to hide his female conquests. The rue Cortot studio was the theater of violent quarrels and occasional blows. Utrillo often disappeared, to be found in some nearby gutter. The name "Forsaken Trio" was rightly earned.

In 1924, Valadon signed a contract with the Bernheim Jeune Gallery. To celebrate the event, the art critic Tabarant gave a banquet in her honor at the lavish Maison Rose. It was attended by several art critics and artists.

Valadon went on painting actively. She was gaining an international reputation and, in 1928, the Munich magazine *Deutsche Kunst und Dekoration* published an extensive and lauda-

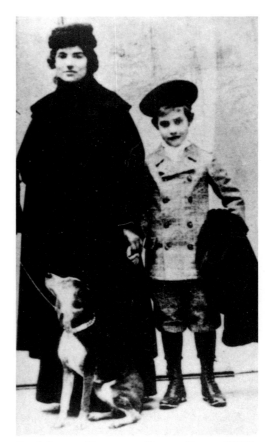

FIG. 3 SUZANNE VALADON AND MAURICE UTRILLO (1894). COURTESY OF GALERIE GILBERT ET PAUL PÉTRIDÈS.

tory article on her work. The following year, Adolphe Basler published a monograph on the artist.

Valadon's artistic success was not duplicated in her private life, in spite of the Trio's extravagant life-style. Valadon had a car with chauffeur, and the couple prodigally entertained their Montmartre friends at Saint Bernard. But

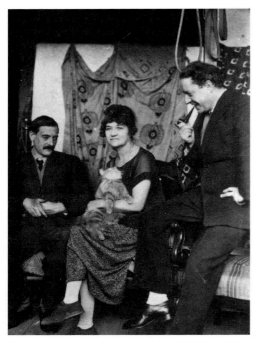

Fig. 4 Suzanne Valadon, André Utter, and Maurice Utrillo at the studio of the rue Cortot. Courtesy of Galerie Gilbert et Paul Pétridès.

Valadon and Utter continued to fight almost incessantly. The owners of the Bernheim Jeune Gallery, who had Valadon and Utrillo under contract, became frightened by the artists' reckless spending. In 1926, the Bernheims purchased a house in Montmartre at 12 avenue Junot, and put it in Utrillo's name. Valadon and her son moved there, while Utter remained in the nearby rue Cortot studio. Valadon's trips to Saint Bernard became rarer, but she still went there until 1932.

An important show of about one hundred of her drawings and etchings took place in 1929 at Berthe Weil. Its catalogue contained a foreword by Robert Rey. But the artist was depressed by her separation from Utter. She worried about her son's future and hoped that he would get married. She thought marriage would bring him the emotional stability he would so desperately need when she could no longer look after him.

At Saint Bernard Valadon had met one of her neighbors, the mayor of Lyon, Edouard Herriot, who later became prime minister of France. He developed a strong admiration for her art and a solid friendship with her. In 1932, the Galerie Au Portique in Paris gave a show of Valadon's recent works.[25] Valadon also took part in an exhibit in Prague that grouped artists from the Ecole de Paris. Simultaneously, she had a retrospective at the Galerie le Centaure in Brussels. That same year, she painted her *Self-Portrait with Bare Breasts*, a magnificent, mature painting that expresses sad resignation to her aging.[26]

In 1932 there were many exhibits as well as positive press reviews for Valadon. Herriot wrote an introductory essay for a major show at Georges Petit gallery. Her drawings and etchings were shown at Au Portique, and the Trio exhibited their works together at the Moos Gallery in Geneva. Furthermore, the engraver Daragnès published a luxurious album of Valadon's engravings containing an essay by Claude Roger-Marx. But, inexplicably, Valadon sold very few of her works, in spite of favorable "critiques."

In 1933, Valadon joined a distinguished women's organization, the Femmes Artistes Modernes (F.A.M.). Its president, Marie-Anne Camax-Zoegger, had her works shown in the Musée du Luxembourg, alongside those of Valadon, who, in spite of her mistrust for "women's art," exhibited her most important works at the yearly F.A.M. salons until she died. Her output had decreased considerably. She had developed diabetes and uremia and experi-

enced constant mood swings. Maurice Utrillo found religion and at fifty was baptized as a Roman Catholic. He prayed daily for several hours; this religious fervor was to last the remainder of his life.

Valadon saw little of her husband, who spent long periods of time at Saint Bernard. Since Utrillo was under contract with art dealers, Utter no longer managed his stepson's lucrative sales. Utter had no money of his own, and he wrote pathetic letters to his wife, pleading poor health and sometimes imploring her forgiveness: "Isolated, without any friend … I did not want to have an operation far from you. Come back near me. I promise you, I swear to you, that your peace of mind, your rights and your freedom will be respected." Utter concluded this letter, written at Saint Bernard: "Don't leave me without news, it is unbearable. I have no money and I can't call you up."[27] Utter continued to write Valadon and to visit her occasionally for the remainder of her life.

In 1934, Valadon developed a tender friendship with a young painter, Gazi, who called her "Mémère."[28] He helped take care of the house and tried to communicate to Valadon some of his religious fervor. But Valadon's last years were shadowed by her sadness at her son's departure. Maurice Utrillo had met Lucie Valore, the widow of a Belgian banker who had collected his works. She was a domineering woman who married Utrillo in 1935 and took him away from his mother's influence. It was said that it was Valadon herself who planned this marriage to be certain that her son would be protected after her own death. But Utrillo left the avenue Junot after a dramatic scene, and Valadon was deeply hurt. She voiced her resentment, "My son never left me during fifty-two years… now that a woman took him away from me, I feel lonely, so lonely."[29] But

in spite of his absence, Utrillo professed a total devotion to his mother, whom he called a "saintly woman."

From 1934 to 1936, Valadon did a few, very beautiful portraits. During the last two years of her life, she mostly painted flowers, pictures that she presented as gifts to her friends.

In 1938, the artist had a stroke while painting. She was rushed to the Clinique Piccini where she died at eleven in the morning. A funeral mass took place at the Church of Saint Pierre de Montmartre. "Tout Montmartre" came to pay its respects. Among the mourners were Picasso, Max Jacob, Derain. Francis Carco, André Salmon, and Edouard Herriot gave the eulogies. Valadon was buried next to her mother at the cemetery of Saint Ouen.

1. It seems that whenever Valadon's career took a new direction, the artist felt the need to adopt a different surname. Maria and Suzanne were fashionable names at the time Valadon chose them. In the letters Degas sent her from 1890 to 1917, he always called her "Terrible Maria." c.f. Paul André Lemoisne, *Degas et son œuvre*, N.Y., 1984, pp. 76, 180, 193, 200, 250, 257.

2. He was 21 years her junior.

3. She took her maiden name back after her daughter's birth. She was later known as "Maman Madeleine".

4. This information is confirmed by a letter from André Utter to Dr. Le Masle in 1939, and an inquiry from Dr. Le Masle to Mr. Pujol, March 31, 1947. Archives of the Musée National d'Art Moderne, CNAC Georges Pompidou, Paris.

5. Baron Georges Haussmann (1809-1891), Préfet de la Seine, was put in charge of the modernization of Paris during the reign of Napoleon III. For a discussion of "Haussmannization," see T. J. Clark, *The Painting of Modern Life. Paris in the Art of Manet and His Followers*, N.Y. 1985, pp. 23–78.

6. A "butte" is a hilltop in French. It became the name of the upper part of Montmartre.

7. A large coastal city in the southwest of France.

8. Although Valadon changed her surname in 1883, she is referred to as Suzanne throughout this book.

9. This information is substantiated by the answers to a questionnaire sent by André Utter in 1939 to Marie-Emilienne Coca, Valadon's grandniece, and confirmed by the latter's daughter, Marie Coca, in a letter to Dr. Le Masle, March 9, 1939. Archives of the Musée National d'Art Moderne, CNAC Georges Pompidou, Paris.

10. Marie Coca to André Utter, January 28, 1939, Archives of the Musée National d'Art Moderne, CNAC Georges Pompidou, Paris.

11. Document in the Archives of the Musée National d'Art Moderne, CNAC Georges Pompidou, Paris.

12. The most famous circuses were the Cirque Fernando, the two Hippodromes, and the private Cirque Molier.

13. Valadon modeled for Puvis from 1880 to 1889.

14. She posed for Renoir from 1883 to 1887.

15. She posed for Toulouse-Lautrec from 1884 to c. 1889.

16. For more details on models' condition, see Jacques Lethève: *La vie quotidienne des modèles*, Paris, 1968, pp. 78–79.

17. These names were quoted by Valadon in a questionnaire she filled out for *Prométhée* in 1938. "Suzanne Valadon par elle-même," March 1939.

18. André Utter, *How to Become a Painter*, handwritten manuscript, Archives of the Musée National d'Art Moderne, CNAC Georges Pompidou, Paris.

19. Ibid.

20. Letter of Marie Coca to Dr. Le Masle, September 3, 1959, Archives of the Musée National d'Art Moderne, CNAC Georges Pompidou, Paris.

21. Located in the Saône Valley.

22. See *Black Venus* (fig. 10) in Chapter III.

23. For Valadon's exhibits, see Chronology.

24. Utter, *How To Become a Painter*.

25. The catalogue contained a foreword by Herriot.

26. See an analysis of this work in Chapter III, fig. 3.

27. Handwritten letter, signed "Utter," September 27, 1934, Archives of the Musée National d'Art Moderne, CNAC Georges Pompidou, Paris.

28. An affectionate French term meaning "little mother."

29. Michelle Deroyer, *Quelques souvenirs autour de Suzanne Valadon*, Paris, 1945, p. 183.

CHAPTER I

CHILDREN

*One should never put suffering in drawings,
but all the same one has nothing without
pain. Art (is here) to eternalize this life that
we hate.*

—SUZANNE VALADON OU L'ABSOLU[1]

T he suffering that Valadon hoped to avoid in her drawings could not be successfully erased from her art. It dominates her images of children; the youths' sorrow and alienation, as well as their occasional deprivation, are the obsessive themes of her early works. For over three decades, she drew representations of small boys and girls. They look pensive, often clumsy, but most importantly,

lonely. Eventually, they seem to become resigned to their solitude. It is assuredly the estrangement of the artist's own early years that surfaces in these stark portraits.

Unable to suppress her past suffering, Valadon "eternalizes" it with such novel images, with such powerful graphic eloquence, that she creates an art as unique for her time as it is for ours.

On April 25, 1894, Suzanne Valadon exhibited at the Salon d'Exposition Nationale des Beaux Arts in Paris. For this most important show, the artist chose five drawings that dealt with the theme of childhood and for which she used the same sitters, a nude boy and an elderly woman.[2] The drawings broke all the existing conventions associated with representations of children. During the nineteenth century, these images still followed a strict iconographic code that presented happy children sheltered by their loving family. The stark realism of Valadon's works, depicting the sitters' pathos and physical awkwardness, as well as a nudity that bordered on nakedness, could instill an uneasiness in the viewer. The drawings also might have appeared reprehensible since they exposed not only the genitals of anonymous children but also those of her own son, whom she drew in the nude until the age of thirteen. Furthermore, there were in the drawings psychological implications of loneliness and even maternal abandonment: Maurice is mostly depicted playing by himself or indifferently tended by an unattractive older woman. Valadon's portrayal of small girls is even more disturbing and often speaks of a plea for love and of rejection, alienation, and even despair.

Representations of children, from antiquity to modern times, have always been codified. This is why, when Valadon exhibited her drawings at the Nationale, more than the children's nudity or their physical deprivation, it was Valadon's frank handling of their unhappiness that could offend the viewers. Contemporary images of children were restricted to a few types shown with variations and handed down from centuries of use.[3] Most artists adhered to the severely restrictive rules, although there were a few exceptions. For example, in the late eighteenth century and the beginning of the nineteenth, Elisabeth Vigée Lebrun attempted to instill some warmth and individuality into the portrayal of children, including those of royal blood. Her sitters look contented, loving, and seemingly loved in return as they nestle on their mother's lap or gather happily around her. However, their pose is as artificial as their smiles and they function as members of a ready-made family and play faithfully the part that is assigned to them. They are but happy models in the role of happy children whose spontaneity has been rehearsed.

Interest in children, which had slackened during the Empire and Romantic eras, was revived during the second part of the nineteenth century. Because of a rapidly changing economic and social order, the importance of the family grew and young boys and girls began to reappear in contemporary paintings and sculptures. Infant mortality decreased significantly, public education expanded,[4] and new laws were passed to reduce child labor. The profound alteration that had taken place within the family structure also brought forth a new awareness of the need for affection in children and parents.

The format of art also experienced changes. The size of the works was scaled down, and the "machines," those huge and prestigious historic scenes, were replaced by easel paintings more in proportion to the smaller lodgings of the bourgeoisie, the new class of art buyers. But if the dimensions of art works were different, the

images were not. Inviting goddesses were still surrounded by flying putti whose innocence remained a ploy to enhance Venus or Juno's erotic message. Secular themes were superimposed on religious ones, as *Madonna and Child* became *Mother and Child*, the new venerated icons of a republican state. Young saints gained a new popularity on their own, or as a welcome addition to the family circles.[5] Most of the recycled images shed their element of formality to celebrate the natural warmth of the parental relationship. Even the iconoclastic Impressionists painted tender portraits of their offspring playing peacefully in blooming family gardens as, for instance, the young Jean Monet does in *Madame Monet and Child*.[6] Mary Cassatt's nieces and nephews nestled affectionately on their mother's knee, and the aristocratic young Julie Manet, Berthe Morisot's daughter, never ventured far from her parents' discreet guidance.[7]

It was not only child iconography that was restricted to few prototypes but also the concepts behind these representations. The youngsters shown had to be healthy, happy, and protected within the family circle, although brutal descriptions of abusive child labor and alcoholic parenthood—substantiated by real-life cases—sprang from the pens of such contemporary writers as Emile Zola and Alphonse Daudet. Even naturalistic painters did not break the unspoken rule and presented children who worked enthusiastically for ten hours a day. For the images of well-loved, well-fed, and idle bourgeois children, the Realists substituted the images of well-loved, well-fed, but enterprising working-class children who took joyous part in the survival of their economically deprived families, as shown in Bastien Lepage's *Small Bootblack*.[8]

The code was broken by Suzanne Valadon, whose children never looked rosy-cheeked or contented. Her brand of realism, a far cry from that of Bastien Lepage's, accentuated the children's unhealthy look and their obvious mental insecurity. Her frank representations were unsettling images that had no place within the realm of contemporary French art and might have seemed, to the nineteenth-century viewer, closer to child pornography. The unspoken conventions that Valadon violated continued to exist in the male-dominated society of late nineteenth-century France. The existing rules reflected the utopian vision needed in a state still regulated by Napoleonic laws that gave total moral and legal powers to men. The functions of the household were entirely in the woman's care, and the hardships of raising children were assumed by the mother in the lower economic classes. But the father still had the final and absolute say in family matters. The manufacture of reassuring images of a happy family with well-adjusted children therefore remained essential in order to demonstrate the validity of the current order. Valadon challenged the myth of these conventions, both morally and psychologically, by presenting children outside of the protective care of the family. Their maladjustment and cries for help were unmistakable.

Drawing was Valadon's first means of artistic expression. In her personal notes she wrote that she "started to draw like crazy at eight."[9] She continued to do so for six years until she gathered the courage to try to paint. Nothing is left of her early efforts, which, by her own admission, she destroyed. Her first extant work is a pastel self-portrait dated 1883.

Although it is generally acknowledged that most of the successful women painters and sculptors were themselves daughters of artists,[10] there was no known artist in Valadon's maternal line who would account for her innate talent and

her irresistible urge to draw. These were not caused by a biological inheritance, but by a geographical factor: Montmartre!

It was there that Valadon grew up and spent her whole life, and it was the small commune's milieu that conditioned her vocation. Montmartre was the source, the background, and finally the catalyst of Valadon's art. Growing up and living most of her life on the Butte, in daily contact with artists, gave her the unique opportunity to become one herself. In Montmartre, and in Montmartre only, could a woman, discriminated against as a female, culturally deprived and of the working class, achieve Valadon's goal: to become an artist and to be acknowledged as one. Valadon had the talent, but it was Montmartre that made her aware of it and gave her the strength and means to develop her gift.

By the 1890s, there were 2500 artists living and working professionally in Montmartre.[11] They seemed to be everywhere, whether they occupied luxurious studios or wooden shacks. They crowded the winding streets and set up their easels near the windmills and vineyards. They canvassed the models' markets and moved from outdoor restaurants to café terraces, endlessly discussing their work wherever they went. From her childhood on, Valadon lived among them and was constantly exposed to art and the men who dedicated their lives to it. Their commitment reinforced her decision to become an artist. She might have suppressed her yearning had she not observed others absorbed by a similar passion; through them she found the justification for her own needs. Seeing them passionately involved in the acts of creation innoculated her against the fear of being different that often stifles children's talents. Her drawing became, if not yet acceptable to her family, at least justifiable in her own eyes.

Valadon, because of her poverty, was never taught the fundamentals of art. Her mother worked up to ten hours a day as a cleaning woman. Bewildered by her daughter's constant "scribblings," she had neither the patience nor the foresight to try to understand her child's unique world. But even had she been more sympathetic to her daughter's vocation, she certainly could not have found the means to pay for basic art supplies or for a modest training in one of the small Montmartre academies that actually charged higher fees for women than for men.[12] Valadon had to learn on her own. As a youngster, she observed the painters sketching in the Montmartre streets and sometimes accompanied her mother to studios that Madeleine cleaned, where she saw other artists at work, drawing or painting.

Much has been written about Valadon learning her art from the artists for whom she posed. She carefully watched their gestures, the way they constructed their work, organized their composition and set up their figures. But even if her patrons did influence her work, the larger part of the credit for learning still must go to the artist herself. Since she wrote in her personal notes[13] that she started to draw at the age of eight and only began to model and be in frequent contact with artists when she was fifteen, she must have practiced without guidance for at least seven years. Teaching herself to draw required not only strict self-discipline, but also a faculty of self-criticism. Young Valadon had no mentor to guide her and had to be her own judge. Some probing remarks, found in the same personal notes, aid in understanding her values. Her lack of self-indulgence—"One must be hard with oneself"—and on her awareness of the difficulties of her task—"One does not achieve greatness without hard blows"[14]—helped her set

criteria for her art that were far more severe than those of the most demanding teacher. It took her ten years to do drawings that she found worth keeping. She waited until she was eighteen to keep her first known work. Everything she did before 1883 was mercilessly destroyed.

Valadon's earliest extant work, a pastel *Self-Portrait*, testifies to her talent and instinctive affinity for the medium of drawing. She worked as a professional model from age fifteen to twenty-eight, and most of the artists for whom she posed showed a distinct predilection for line over color. Among them were the classical Puvis de Chavannes, and the eclectic Toulouse-Lautrec, who first exposed her to graphic arts. She also modeled for "Pompiers" like Jean-Jacques Henner, Hector Leroux, and the Realist Giuseppe de Nittis. All these painters were trained in Beaux-Arts ateliers, where the teaching of drawing took a cardinal place and lasted for several years.[15] Most important was Valadon's contact with Degas, whose admiration for her drawings gave her the incentive to pursue her efforts.[16] He became her collector instantly, and his first acquisition was *Standing Nude near Chair*.[17] Degas continued to buy her drawings and hung them in his apartment near the works of Delacroix, Puvis de Chavannes, Manet, Corot, and Kiyonaga.[18] It was undoubtedly Degas who exercised the greatest influence on Valadon's choice of subject matter, technique, composition, and style. Although he did not draw nude children, his graphic shorthand and his pure, uninterrupted line were what Valadon emulated, for instance, in *Nude Girl at Her Toilette*.[19] Defining the subject's contours through a pure single line was one of Degas' most adamant edicts, which Valadon never forgot for the rest of her life. To obtain this continuous unbroken line, she sometimes had to utilize tracing.[20]

Degas thought so highly of her talent that, in 1895, he began to teach Valadon the technique of soft-ground etching on his own press.[21] This medium offers several advantages: it is relatively simple to handle for a beginner and has the texture and appearance of chalk or pencil drawing. In addition to yielding a multiplicity of prints, soft-ground etching also gave Valadon the clarity of line and feeling of spontaneity that she needed for her informal sketches of children. From 1895 to 1920, the artist did thirty-one dry points and soft-ground etchings and three lithographs. Most of them showed nude children bathing in or out of doors, occasionally next to an adult woman.

In 1912, Valadon had a chance to express her gratitude to Degas. When the older artist had to vacate an apartment in rue Victor Massé, where he had lived for twenty-two years, Valadon was most instrumental in finding him a new flat at 6 boulevard de Clichy, also located in Montmartre.[22]

She acknowledged her artistic debt to him in one of her paintings, *Marie Coca and Gilberte* (fig. 4, Chapter II), a group portrait of Valadon's maternal niece and grandniece. On the background wall, the artist placed a picture of a group of ballerinas.[23] This "picture within a picture"[24] was a technique frequently used by Degas but rarely by Valadon. The inclusion of one of Degas' images was Valadon's unequivocal homage to her teacher, her colleague, and her friend.

Valadon's interest in human nature surfaces in her first drawings. Rather than copying the exercises or the reproductions seen in teaching manuals, she sketched those who were close to her: her mother; one of her lovers, Miquel Utrillo; and her son, Maurice, her favorite model. The drawings exhibited at the Nationale were neither dated nor described in the exhibition catalogue. Therefore, it is impossible to offer a

definite identification of the models, but it is most likely that they were her son and her mother. They were her most frequent sitters from 1883, the date of her first known work, to 1896, when she married the wealthy Paul Mousis.

Valadon only left two representations of infants or babies. Her lack of interest in newborns seems paralleled by her indifference to images of motherhood. This subject was treated by many other artists in the late nineteenth century with several formal, thematic, and conceptual variations.[25] It was not until seventeen years after the birth of Maurice that Valadon did her first and only *Maternity*.[26] This work must be seen as a sketch rather than a finished drawing. Valadon has placed the image of a maternal figure with an infant suckling at her breast in the center of the composition. Several babies' heads are scattered at random on the surface of the paper. The nursing female is solidly built, and her vast figure seems to envelop the small shape of the infant crushed against her breast. Valadon's belated interest in motherhood is even more puzzling since there is no follow-up of the theme, save for a small study showing two infants suckling an invisible breast.[27] The nursing woman's face reflects a tender concern for the newborn whom she holds protectively. Her identity and function are difficult to determine. She might be a wet nurse hired by the child's parents, as was often the case with prosperous families. Since Valadon mostly drew impoverished Montmartre dwellers, the portrait is more

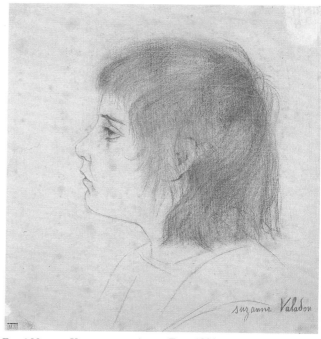

FIG. 1 MAURICE UTRILLO AT THE AGE OF TWO, *1886, RED CHALK ON PAPER, 10³/₄ X 10¹/₄", MUSÉE NATIONAL D'ART MODERNE, CNAC GEORGES POMPIDOU, PARIS, D 2*

likely that of a mother feeding her own child, as the title *Maternity* indicates.

The work is less indicative of the artist's interest in motherhood than of her constant curiosity about scenes in her daily life. Indeed, the sight of woman nursing an infant was as common as that of a pregnant one in Valadon's neighborhood.[28]

Even her own son, when he was an infant, failed to inspire Valadon. She waited until Maurice was two to draw her first portrait of him, *Maurice Utrillo at the Age of Two*, (fig. 1). The child looks older than the age indicated in the title.[29] This work is an unusual one for

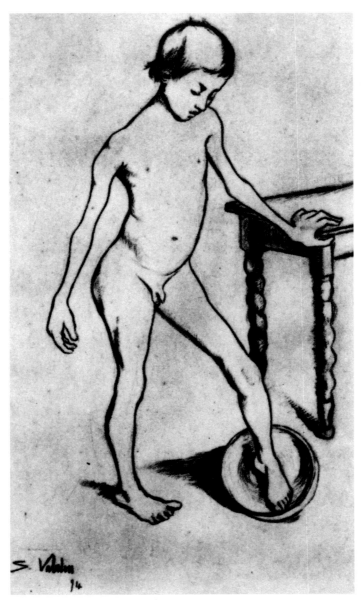

FIG. 2 NUDE UTRILLO PLAYING WITH A BOWL, *1894, BLACK PENCIL ON PAPER,*
16⅛ x 9⅛", PRIVATE COLLECTION, D 26

Valadon who, even at the start of her career, generally displayed a bluntness of line and a decisiveness of contour that seem almost brutal. In Maurice's portrait there are a softness and a tenderness that reveal an unsuspected vulnerability in his mother's personality. The use of the blurry lines of the red chalk is also important in the overall impression of fragile delicacy.

It was not until Maurice reached the age of seven that Valadon began drawing him extensively, either alone or with his grandmother. There are fourteen known portraits of Maurice from the age of two to thirteen. All of these, save for a sketch showing him on his way to school, are nude images. They do not seem to have been formally posed, and they present Maurice engaged in a series of daily activities—getting washed or dried by his grandmother, playing some solitary game, sitting idly by himself, or simply sleeping on a cot.

In *Nude Utrillo Playing with a Bowl* (fig. 2) Maurice is shown leaning on a table, his left foot inside a wash bowl so small that it barely holds his foot. This is not a bathing scene, since the bowl does not contain any water. Maurice seems absorbed in an attempt to roll the empty bowl around in a self-devised game that does not appear to amuse him.

The drawing is simple and there is no indication of decor. However, there is a feeling of immediacy and three-dimensionality created by the intrusion into the illusionist space of details such as the boy's right foot, the bowl, and the table legs that clearly delimit its foreground, middleground, and background. The small body is shown in a contrapposto pose, and the volumes are indicated by lines of different thickness. These lines are pure and energetic but reduced to their absolute minimum. The work indicates an extraordinary assurance. Valadon has unerr-

ingly selected the essential contours that define in shorthand the character of the sitter.

Maurice is shown leaning against a partly hidden table. Only two of the voluted legs are visible, but they do not look like those of bathroom furniture. The inclusion in the decor of what must be a dining room table suggests that the scene takes place in an "all-purpose" room rather than the expensive "cabinet de toilette" found in luxurious homes. By the suggested function of specific objects, Valadon defines the child's social class as he bathes and plays in a room used in poor households for all the family's activities.

In most of her son's portraits, Valadon displays a remarkable quality of objectivity. Sometimes, maternal love breaks through her self-imposed detachment, as when she draws the sensitive *Maurice Utrillo at the Age of Two* (fig. 1). In *Utrillo at the Age of Nine* (fig. 3) the artist has sketched the child asleep on a cot. The bed is obviously too short for the growing boy, and he has to bend his long, skinny legs to fit on it. His angular limbs, the bones of his rib cage, and a glimpse of his unguarded sleep evoke mixed emotions, partly of pity for his vulnerability and awkwardness. But there is also a feeling of uneasiness as the viewer becomes a voyeur. If the onlooker experiences some embarrassment while facing a scene not meant for a stranger's eye, this uneasiness is not motivated by a sexual implication. The nude children, even Maurice, are just seen as children, and Valadon does not allude to their sexuality. They are shown unconcerned by their nudity and oblivious of the eyes that observe them, of the hand that draws them. The artist's frank depictions do not contain any ambiguous undertones. She only directs her attention to the essence of her sitters, an essence eminently too guileless and open to carry any erotic suggestion.

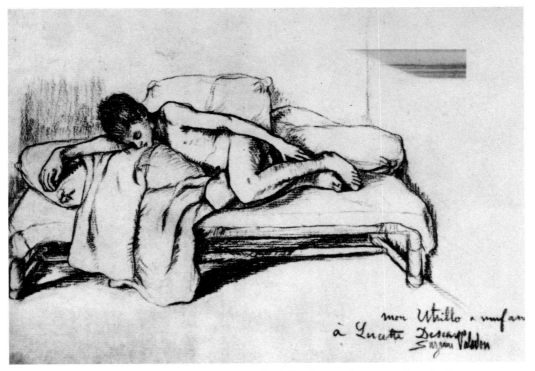

FIG. 3 UTRILLO AT THE AGE OF NINE, *1892,* BLACK PENCIL, *9 X 11¾",* PRIVATE COLLECTION, PARIS, *D 19*

But Valadon must have been unaware of the far-reaching psychological consequences that the repeated nude portraits of her son could trigger. Maurice Utrillo, regardless of his later success as an artist, was a troubled child who became an alcoholic when he was eight. Being drawn in the nude by his mother, as well as being attended by his grandmother while bathing, even after he reached puberty, might have created sexual problems that could be at the source of his psychological imbalance. In *Nude Utrillo and Sitting Grandmother* (fig.4), as in numerous drawings, his grandmother is shown standing at his side, a towel in her hand, ready to dry him as he steps out of the tub, his genitals exposed to her gaze.

It is her efficiency and her care for the child's physical welfare that is stressed rather than her love for him. However, even if Maurice's solitude is undeniable, he does not seem to resent it. It is his introverted personality that surfaces in his portraits, as Valadon often pictures him daydreaming or lying down quietly. She never shows herself at his side, choosing her role as artist over that of mother.

When Valadon places women next to children, they are grandmother, servant, bathing companion—never mother.[30] Nor does Valadon

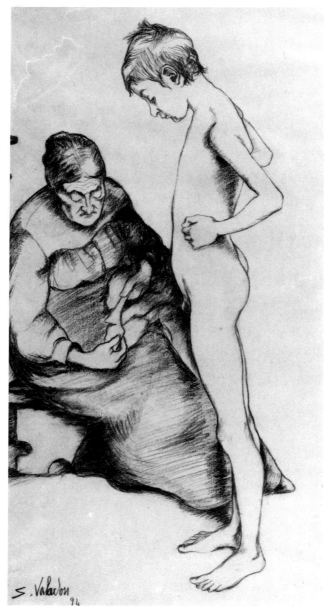

FIG. 4 NUDE UTRILLO AND SITTING GRANDMOTHER, *1894,* BLACK PENCIL
ON PAPER, COLLECTION PAUL PÉTRIDÈS, PARIS, D 27

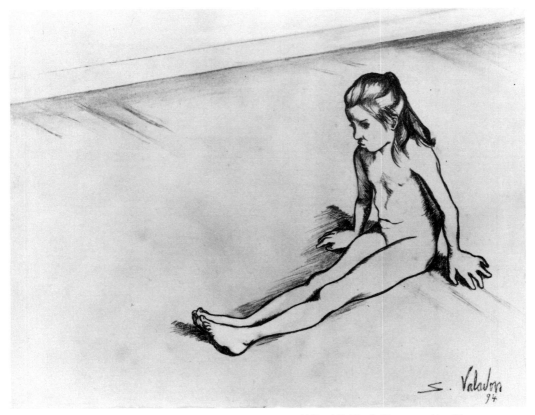

FIG. 5 NUDE GIRL SITTING, *1894, BLACK PENCIL AND WHITE CHALK, 11⅝ x 11", MUSÉE NATIONAL D'ART MODERNE,* CNAC GEORGES POMPIDOU, PARIS, D 33

include the comforting image of a father, or of any male adult. There was no paternal love or protection in the artist's childhood, and there is none in the lives of the youngsters she draws.

Besides her son, Valadon sketched several children, mostly girls. They are young adolescents from her neighborhood, pubescent girls, grown up too fast, uncertain of their identity as child or adult. They are shown in the same daily activities as is Maurice; Valadon draws them in the nude and apparently unaware of her gaze.

Frequently, she captures them involved in some bathing ritual, climbing in or out of a tub. Occasionally they are washed or dried by an elderly grandmother or a maid, or seen combing the hair of a female companion, also nude.

The theme of child alienation, sadness, and rejection recurs throughout Valadon's œuvre but appears most frequently in her drawings of small girls, who, unlike Maurice, often seem to be in a severe state of despair. In *Nude Girl Sitting* (fig. 5) the child holds back her tears, and her face

reflects an intense unhappiness. This sorrow is shown through very simple but very effective means—the frown on her brow, the pouting lips. She sits stiffly on a wooden floor where, nude, she holds herself back by leaning on her hands. Valadon has oversized these hands that lie flat on the ground as if they were meant to help the little girl bear the weight of her despair. The scene is reduced to a minimum, and the artist's "wicked and supple"[31] line reveals the essence of the drama. The form is defined through its total unity rather than through separate details. There is a stoic quality expressed by means of a simplicity of composition and line.

In this drawing, as well as in several other works, Valadon's intense characterization is translated through the deliberate distortion of certain forms, the importance of which is enhanced by their unexpected size. For instance, the over-developed hands of the sitting girl become the receptacle of her sorrow while the unrealistic length of her legs points to the awkwardness and disproportion of the body of a child growing too fast.

Most of the time, the children's alienation is expressed through reductive images whose effectiveness is enhanced by their simplicity. An example of this abbreviated line is found in *Nude Girl Sitting on a Cushion* (fig. 6). The dejected adolescent becomes the focal point in a bare room, her head and shoulders bent while her arms rest listlessly on her lap as if she had lost the strength or the power to move them. In her foreshortened face, where there is no room for emotion, only a small nose and a lowered eye can be seen. But Valadon has succeeded in evoking the child's distress through body language, using an attitude rather than a facial expression to convey a mood.

Some of the artist's most expressive means of communication are the sitters' gestures, which become the key to a small drama. In *Crouching Nude Holding Grandmother's Skirt* (fig. 7) a nude girl squats on the floor next to an elderly woman, who turns her back to her. She tries to reach the skirt of her companion with her extended arm. The gesture resembles that of a

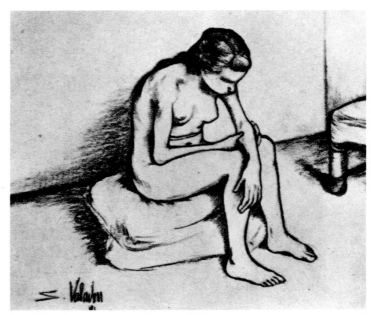

FIG. 6 NUDE GIRL SITTING ON A CUSHION, *1894, BLACK PENCIL WITH WHITE CHALK, 8⅝ X 11", MUSÉE NATIONAL D'ART MODERNE, CNAC GEORGES POMPIDOU, PARIS, D 33*

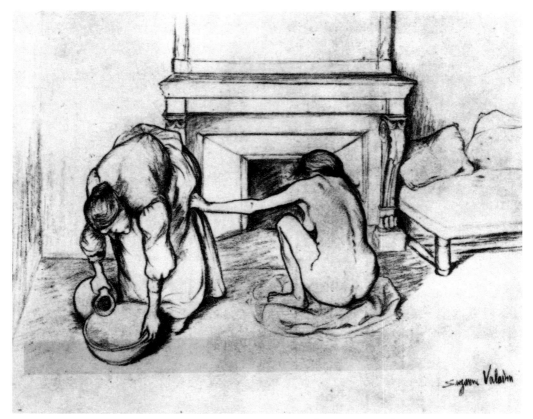

FIG. 7 CROUCHING NUDE HOLDING GRANDMOTHER'S SKIRT, *1909, CONTÉ CRAYON, 13 X 16½", PRIVATE COLLECTION, D 148*

sightless person who needs to touch what she cannot see in order to find reassurance. It is this pathetic reaching out, with its unmistakable request for affection, that is infinitely moving. In 1895, Valadon had done a less detailed version of this drawing that she called *Louise Holding on to Catherine*.[32] This kind of situation, with implications of parental shortcomings, was avoided by Valadon's contemporaries, even by the Realists.

It was mostly through such images that Valadon exposed some children's unfulfilled needs for affection and their feelings of alienation. The scene in *Crouching Nude Holding Grandmother's Skirt* might also reflect the artist's unhappiness during her own childhood. As a baby she was left to the indifferent care of a local concierge; as a small child she was sent to stay with hostile relatives by her mother, who was too overworked to take care of her.

In 1913, Valadon did a black pencil drawing that she titled *Young Girl Hiding her Forehead*

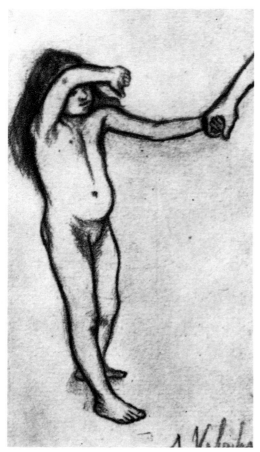

FIG. 8 YOUNG GIRL HIDING HER FOREHEAD, *C. 1913–14,* BLACK PENCIL, *6 ¾ x 3 ¾", COLLECTION PAUL PÉTRIDÈS, PARIS, D 180*

(fig. 8). The simplicity of the scene heightens its dramatic effect. The image of a small nude girl occupies most of the left side of the work. She appears to be walking, since her right foot is extended forward as in a stride. Her long hair falls freely on her shoulders, and the upper part of her face is almost hidden by her right forearm

in a gesture of embarrassment or sorrow. She seems dragged by her extended left hand, which is linked to the lower right arm of an unseen person. The strength of the scene is enhanced by the abruptly severed arm, the size of which would indicate that of an adult, probably the child's mother. The incongruity of the floating partial limb, so abruptly cut, indicates Valadon's knowledge of the cropping techniques used in Japanese woodcuts and also in photography. The fierce, bold lines and the heavy-handedness of the contours give the composition a psychological realism that is striking for its time.

The subject of the rejected young girl hiding her forehead had great importance in Valadon's iconography since she had done two versions of the same theme. The earliest, *Women and Children near the Water,*[33] is a dry point that Valadon treated as an outdoor bathing scene. In it, the little girl seems to be dragged by her mother toward the water. The gesture of hiding her face undoubtedly expresses fear, shame, or distress. Valadon was certainly conscious of the effectiveness of the child's attitude since she repeated the image in a second drawing done c. 1913–1914, *Woman and Small Child near the Water,*[34] where the scene centers around the nude mother whose tall body dwarfs the child's diminutive frame, enhancing the girl's helplessness. Valadon still retains the semblance of an outdoor setting with the suggestion of two tall trees. The artist's draftsmanship and her unfailing sense of theatrical statement can be best appreciated in her handling of the three successive states of a same drawing, where her elimination of unnecessary details culminates in a final image that stands as the essence of the unfolding drama. Valadon selects the lines that best define the model's personality and, through a rigorous rejection of inessential elements, achieves with

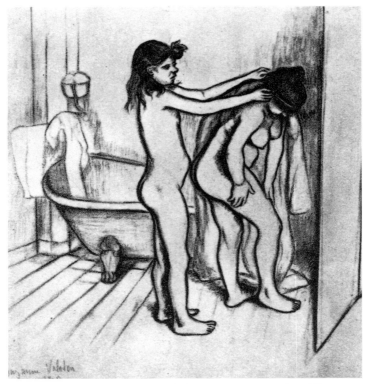

FIG. 9 TWO NUDES AFTER THE BATH, *1908, CRAYON AND PASTEL, 12 X 11", PRIVATE COLLECTION, D 132*

stark simplicity a work of the highest psychological and aesthetic quality.

Valadon's drawings, particularly those of children, illustrate her keen observation. The impact of her simple images is enhanced by the choice of few details, whose specificity gives to the scene its unique character.

Perhaps because of Degas' influence, or in order to justify the children's (as well as the women's) nudity, most of Valadon's scenes involve bathing, as in her dry points and soft-ground etchings. In 1908, she did a series of drawings on the theme of young girls, often shown with mature women and innocently engaged in their toilette. They gather around the tub, dry each other's hair, but it is usually the child who cares for the woman.

In *Two Nudes after the Bath* (fig. 9), a child fastens her companion's hair. The woman's heavy body and full breasts offer a startling contrast to the adolescent's skinny and flat-chested figure. Valadon gives us a detailed description of the bathroom where the models stand. In most of Valadon's drawings the bathing activities center

around a small movable tub set at random on the floor of possibly the apartment's only room. However, in *Two Nudes after the Bath*, a partly hidden but full-size bathtub with one visible claw foot occupies the upper left side of the composition. The narrow planks of the floor are set in an obliquely ascending pattern that is a reminder of Degas' use of diagonal space.

Although this is an intimate scene, there is no apparent closeness between the two sitters. The older woman in particular seems oblivious of her companion's assistance and is concerned with drying her own body. The latter is solemn but somewhat detached, and there is no trace of the playful atmosphere often present in conventional scenes "à la toilette". One detects a palpable quality of resignation in the girl, whose assistance is not acknowledged. This work, as do many of Valadon's drawings of children, suggests the overt rejection experienced by a small child. The body language of the models translates their feelings: the child extends her arms as in an offering, while the woman's back and bent body speak of defensiveness and hostility.

In Valadon's early works all the boys were modeled by her son until he turned thirteen. However, the artist's interest in children did not cease when Utrillo grew into a young man. For instance, *Head of a Sleeping Child*[35] is from 1922, one year before she abandoned drawing to devote herself exclusively to painting. Although she did fewer images of children in oil,[36] the theme of *Grandmother Dressing a Little Girl*[37] and *Grandmother Putting Shoes on a Little Girl*,[38] both painted in 1931, reflects her ongoing concern for the state of mind of children raised by a grandparent. In these two works each of the small girls displays a curious state of apathy. Each face looks as vacuous as that of a doll, each body stiffens as the girls commit themselves

into the proficient hands of the older woman, perhaps a grandmother. The overall mood is uneasy, even threatening. We look into a lifeless scene, as frozen in time as a movie still. The girls stand apathetically, their faces untouched by animation or emotion. The unhappiness and alienation so deeply perceived in the artist's earlier children's representations have given way to a more dramatic implication of resignation.

The 1931 paintings were Valadon's final images of childhood. They demonstrate the artist's pessimistic outlook on the familial and social difficulties of child-raising. This negative attitude was undoubtedly brought about by Maurice Utrillo's early personality problems as well as by her own loveless youth.

At times Valadon borrowed her imagery from traditional sources, and did several drawings and a few paintings on the theme of a woman (or girl) with a mirror. In *Young Girl with a Mirror* (fig. 10) a nude girl is holding a mirror in her right hand while the left is raised to her shoulder. She twists her head and tries to catch her own reflection. The scene is so candid that it rejects any hint of sexuality. Valadon's depictions of youngsters are never permeated by any undercurrent of sexual equivocacy; the adolescents' nudity is incidental and their sole preoccupation is curiosity about their own images.

The world of children held strong ambiguities for the late nineteenth-century art world, and contemporary exhibitions displayed occasional paintings and sculptures offering equivocal images of nymphets.[39] However, none of Valadon's representations of children contain any suggestion of sexual perversity, either covert or in the open. *Young Girl with a Mirror* simply deals with a child trying to catch her own reflection in a mirror. Neither can this scene be called a "vanitas."[40] It stands

as a piece of Valadon's perceptive reporting on children at play.

Although Valadon has not left any sculpture that we know of, her draftsmanship has sometimes been compared to a sculptor's. Through the energy of her lines and the strength of her contours she seems to create her forms out of a block of space. Her vigor of execution, superficially perceived as hardness, is a self-imposed strictness born of an uncompromising desire to render what she sees, regardless of its aesthetic appeal—a concern far ahead of her time. Having seized her subject, she distills it to its essence.

Her drawings are severe and implacable. Her lines shed all decorative function to exist by themselves and for themselves. They have been judged by some contemporary critics as "unfeminine" or "virile"[41] because of their reductiveness. Her art, regardless of its initial spontaneity, is channeled through a methodical organization that purifies and summarizes through a few essential strokes to achieve a synthesis often seen in the works of Degas and Toulouse-Lautrec. However, her lines are too strong to be linked to Degas and too candid to be those of Toulouse-Lautrec. They are uniquely Valadon's.

The artist never "posed" her subjects, children least of all. She observed them but did not require a pose, in contrast to Degas, who demanded from his models an absolute stillness. Valadon did her best work as she watched her models "living." Her settings are almost bare and her accessories limited to tub, sponge, or towel. She was particularly fond of bath scenes, as were Degas, Toulouse-Lautrec, and Forain, all devoted heirs of the Utamaro tradition. At times, Valadon draws her figures against an empty background that allows her to emphasize the value of a movement, the weight of a gesture, made more resonant in the emptiness of a blank space. In *Young*

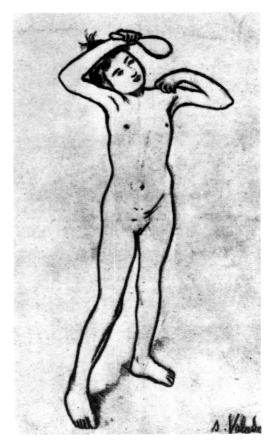

FIG. 10 YOUNG GIRL WITH A MIRROR, *C. 1909, BLACK PENCIL, 13 X 7½", PRIVATE COLLECTION, D 152*

Girl with a Mirror she places her model on a white background that focuses attention on the child's concentration as she intensely looks at her own reflection.

Valadon's renditions of models—women and children—in a graphic nudity so unusual for her time, liberate them from the constraints of their clothing and allow her to render more succinctly the expression of their movements.

She always chose them from her neighborhood of Montmartre. Her adult females, frequently from a rural background, are unsophisticated people who had left their villages to try to find employment in the capital. They seem unperturbed by the artist's presence, since her gaze is unobtrusive and nonjudgmental.

The children, puny, sometimes underfed or uncoordinated, are heirs of Gavroche[42] or contemporaries of Poulbot,[43] whose creator was Valadon's neighbor in Montmartre. None of the youngsters seem rooted in the same world as Cassatt's pink, dimpled, and secure small girls or Morisot's aristocratic teenagers.

Her women are monumental, mother earth images who stand as solidly on their robust limbs as Courbet's female peasants. Valadon renders their faces and bodies with an almost caricature-like deftness, inspired perhaps by Toulouse-Lautrec, and with incisive strokes she exposes the salient traits of their character. The most striking quality found in her entire œuvre and particularly in her drawings, is her freedom of expression, unseen in the works of women artists of her time. Her candidly honest representations extend far beyond contemporary concepts of pictorial realism and they form the counterpart to Emile Zola's literary naturalism.

Valadon's disregard for established iconography did not primarily stem from a deliberate defiance of the existing order or a wish to impose her personal vision. Her freedom of expression was unhampered by any artistic training. What she knew about art was, for several years, instinctive. Later on, when she started to pose, she intensely watched the artist working and through her observation acquired the rudiments of her technique. Following her modeling sessions, she had the opportunity to observe the drawings and paintings in progress in the atelier and to learn, in an indirect fashion, the fundamentals of the artist's metier. But since she posed in the nude,[44] she accumulated an extended knowledge in this genre. Most of the painters for whom she worked had no interest in representations of children—save for Renoir. Even the works of her academic patrons, such as Henner or Leroux, contained only limited appearances of young St. John the Baptist or winged Eros.

When Valadon became involved in drawing her son, she had no role model and few artistic references to guide her. And yet, it is in her images of children that she displays her most daring innovations, both thematically and stylistically. They are spontaneous renditions of a subject about which she had no preconceived notions. With innocence she drew these haunting images, with an unchanneled energy she created these incisive strokes so solidly imprinted on the paper, and with an unerring eye she selected the raw deformations of her forms. With all these factors, and more, she achieved a remarkably blunt psychological realism before any other woman artist of her time.

1. *Suzanne Valadon ou l'absolu*, Archives of the Musée National d'Art Moderne, CNAC Georges Pompidou, Paris.

2. Exposition Nationale des Beaux Arts, *Catalogue illustré des ouvrages de peintures, sculptures, dessins, gravures et objets d'art et architecture exposés au Champs de Mars*, April 25, 1894. The works exhibited were: 1670 *La Toilette du Petit Fils;* 1671 *Grandmère et Petit Fils;* 1672 *Etude d'Enfant;* 1673 *Etude d'Enfant;* 1674 *Etude d'Enfant;* 1675 *Etude d' Enfant.*

3. For a detailed exposé of children's images in the nineteenth century see Claire Barbillon "Images de l'enfant, Mythe et Réalité" Conférences du Musée d'Orsay, *Quarante Huit/Quatorze*, No. 2, Paris, 1986.

4. See *Histoire de la famille*, edited by André Burguiére, Paris, 1986, p. 375.

5. As illustrated by Paul Delaroche, *Les joies d'une mère*, n.d. Musée Pescatore, Luxembourg; also by William Emile Bouguereau, *Le sommseil*, 1894. Collection Tannenbaum, Canada.

6. Claude Monet, *Mme. Monet and Child*, 1875.

7. Berthe Morisot, *Eugène Manet and His Daughter at Bougival*, 1881.

8. Jules Bastien Lepage, *Le petit cireur de bottes*, 1887, Musée des Arts Décoratifs, Paris.

9. *Suzanne Valadon ou l'absolu.*

10. See *Women Artists 1550–1950*, Ann Sutherland Harris and Linda Nochlin, exhibition catalogue, Los Angeles County Museum, N.Y., 1977, p. 43.

11. See Michel Melot, *Les Femmes de Toulouse-Lautrec*, Paris, 1985, p. 7. By the late 1800s there was a total of 14,000 artists living in the twenty arrondissements of Paris. Montmartre is located in parts of the ninth and eighteenth arrondissements.

12. For details on teaching academies available to women, see Barbara Weinberg, *The Lure of Paris*, N.Y., 1991, p. 218.

13. *Suzanne Valadon ou l'absolu.*

14. Ibid.

15. See Albert Boime, *The French Academy and French Paintings in the Nineteenth Century*, N.Y., 1971, pp. 16 and 17.

16. She never modeled for Degas.

17. *Standing Nude near Chair*, 1894, conté crayon, 9½ x 7", D 23. On Degas' acquisition, see *Suzanne Valadon*, Catalogue, Musée d'Art Moderne, Paris, 1967, p. 83 (# 115) and p. 96 (# 93).

18. Lemoisne, p. 496.

19. *Nude Girl at Her Toilette*, 1894, black pencil, 26⅜ x 24", D 32.

20. Interview with Geneviève Barrez, September 7, 1992.

21. In the soft-ground process a pliable ground is applied over the surface of a metal plate. The artist draws the image with a pencil on an unglazed paper. The pressure of the pencil adheres to the surface of the paper, thus exposing areas of the plate that are then bitten in a bath of Dutch Morant acid.

22. For more details on Valadon's role in finding a new flat for Degas, see *Degas*, Galeries Nationales du Grand Palais, Paris, 2/8/1988; National Gallery of Canada, Ottawa, 6/16 to 8/28/1988; The Metropolitan Museum of Art, 9/27/88 to 1/8/89. Catalogue published by The Metropolitan Museum of Art and National Gallery of Canada, Ottawa, 1988, p. 496.

23. The dancers are shown performing on the stage in a scene reminiscent of those done by Degas during the 1880s.

24. Images represented within a painting, offering clues as to the narrative of the work in which they are seen. For a detailed account of "pictures within pictures," see Theodore Reff, *Degas, the Artist's Mind*, N.Y., 1976, pp. 90–146.

25. Linda Nochlin, *Women, Art and Power and Other Essays*, N.Y., 1988, pp. 36–57.

26. *Maternity*, c. 1900, black pencil, 6⅝ x 15¼", D 71.

27. *Two Infants Suckling*, c. 1900, black pencil, 11½ x 15¼", D 70.

28. Some of Valadon's images are ambiguous and could be read as representations of a pregnant woman. The portrait of the poet Adrien Farge, for instance presents a nude woman with a distended abdomen reclining on an armchair. *Portrait of the Poetess Farge*, 1909, conté crayon on paper, 11 x 14", private collection, D 150.

29. The 1886 dating of this sensitive drawing is questionable on the basis of physical appearance. It is the opinion of the writer that this work should be dated a few years later. Maurice's profile seems to be that of an older child whose firmly set features have shed the uncertainty that characterizes the faces of very young children. Additionally, there is no other drawing of Maurice Utrillo until 1889, D 9.

30. Save for the two "maternities" where she shows a woman—perhaps even a wet nurse—breast feeding an infant. See footnotes 27 and 28.

31. Lemoisne, p. 203. The expression was used by Degas to characterize Valadon's drawing.

32. *Louise Holding on to Catherine*, c.1895, private collection, D 52. I am very grateful to Diane Kelder for

calling my attention to the influence of Degas' monotypes on these works. In his series of prostitutes in brothel settings (c.1879–1880) some of the women are shown extending their arms in a gesture similar to Louise's. See, in particular, *Le Client Serieux* c. 1879 and *Dans le Salon d'une Maison Close*, c. 1879.

33. *Woman and Children near the Water*, 1904, etching, 7½ x 9", E 6.

34. *Woman and Small Child near the Water*, c. 1913–14, pastel and gouache, 20½ x 12⅝", D 186.

35. *Head of a Sleeping Child*, 1922, black pencil, 7 x 4¾", D 259.

36. Valadon did sixty drawings but only sixteen paintings of children.

37. *Grandmother Dressing a Little Girl*, 1931, oil, 31¾ x 25¼", collection of Mr. and Mrs. Marcel Kapferer, Paris, P 425.

38. *Grandmother Putting Shoes on a Little Girl*, 1931, oil, 36½ x 28¾", collection of Miss Kebaili, P 426.

39. For a discussion on the ambiguity of some representations of children, see Bram Dijkstra: *Idols of Perversity, Fantasies of Feminine Evil in Fin de Siècle Culture*, N.Y., 1986, pp. 185–188.

40. Vanitas: a work containing a hidden allegory on the transience of worldly things and the inevitability of death. The meaning is conveyed by the use of familiar and everyday objects, which are given symbolic connotations.

41. Gustave Coquiot, *Cubistes, Futuristes et Passeistes*, Paris, 1923, p. 165, "Elle ne se contente pas de peindre virilement"; Frank Elgar, *Carrefour*, 3/12/1967, "La plus virile des femmes peintres."

42. Character from Victor Hugo's *Les Misérables* who symbolizes the brave and saucy Parisian boy.

43. French caricaturist (1879–1946), whose name also came to stand for a witty and touching young boy.

44. For a contemporary account of a model's life in the late nineteenth century, see Paul Dollfus, *Modèles d'artistes*, Paris, 1906, p. 140. Posing in the nude was a speciality that was highly paid at the time.

WITH REFERENCE TO THE CATALOGUE NUMBERS IN PAUL PÉTRIDÈS' L'ŒUVRE DE SUZANNE VALADON, PARIS, 1971:

D = DRAWING
P = PAINTING
E = ETCHING

CHAPTER II

PORTRAITS

I paint people to learn to know them.

—SUZANNE VALADON OU L'ABSOLU

P ainting people to learn to know them
was Valadon's lifelong endeavor. She
recorded the images of those sur-
rounding her, as well as her own. From her first
existing pastel (1883) to the final important
oils done in 1937, she maintained her interest
in portraits.[1] She loved her art and she loved
people. Using one to discover the other was a
spontaneous act for her. Her canvas and brush
gave magical access to her own inner self
and those of her sitters. Valadon painted these
representations with honesty, candor, and
an intuitive perspicacity that uncovered the

varied natures of the models and became the embodiment of their souls.

It is with her portraits that one can best measure the magnitude of Valadon's talent and the innovative aspect of her art. In over fifty years of portraiture, from her first *Self-Portrait* in 1883 (fig. 1) to that of her dealer, Paul Pétridès, in 1934 (fig. 9), one can trace the evolution of an art that began on an academic basis, achieved its maturity in Expressionism, and developed an essential simplicity that ultimately characterized it as Valadon's own.

During the nineteenth century, portraiture in France underwent profound changes. Until then, traditional and accepted portraits were predetermined and faithful images of the sitter. During the early part of the century it was Géricault who, with his portraits of the mentally ill, went beyond the artist's designated function of social reporter by shifting the focus from corporal representations to spiritual and psychological ones.[2] Géricault dealt with clinical images of the insane, but his influence was curtailed by the limitations of his subject. Photography, during the second half of the century, offered the mechanical means to preserve an individual's likeness; meanwhile Impressionist painters were most preoccupied with the formal aspects of the composition and the importance of the contemporaneity of the subject.

Later came Van Gogh and Gauguin. Unconcerned with physical likeness, they looked for a characterization of the sitter through the means of visual confrontation, intense color, and descriptive brush strokes. Gauguin utilized pictorial effects borrowed from primitive art that gave to his style some of its innovative decorative aspect.

Valadon was aware of the extraordinary talent of Gauguin and Van Gogh. She had met the latter at Toulouse-Lautrec's atelier,[3] and most probably saw Gauguin's exhibition at the Café Volpini.[4] These encounters took place at a time when her own art was still that of a draftsman. The dramatic style of these two painters and their use of color had a powerful influence on Valadon's art, and their techniques were integrated gradually into her work. Her early portraits retain the aspect of drawings heightened with color. Her instinctive graphic artistry was gradually enhanced by a controlled utilization of pure color imprisoned by heavy dark outlines. To evoke the sitter's personality, she avoided the traditional but limited encoded clues in favor of lines, colors, and textures. Ultimately, it was her own qualities, her own style, which transcended her technical achievements in order to animate her sitters.

Valadon's exposure to "modern life" played a major role in her painting. During the nineteenth century printing techniques were developed with extraordinary speed and powerfully affected the diffusion of commercial and fine arts. Reproductions of works from various artists decorated the pages of numerous publications from the Catholic *Journal des Demoiselles* to the *Petit Journal Illustré*. These inexpensive newspapers contained several colored illustrations. The satirical press exercised a strong influence on graphic arts. Salis's *Le Chat Noir*, Félix Jouen's *Le Rire*, and *Le Journal Amusant* were rooted in Montmartre and were within the reach of Valadon.

Inexpensive art-instruction manuals were available to amateurs and professionals alike. The most popular series, *Cours de Dessin*, was conceived by Léon Cogniet and lithographed by Bernard-Romain Julien. Graduated to accommodate various technical skills, the manuals contained numerous copies of works from

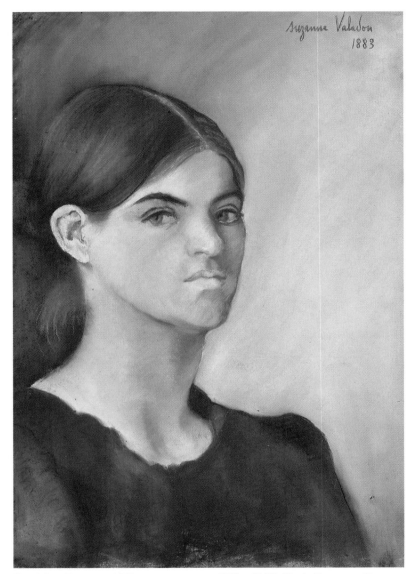

FIG. 1 SELF-PORTRAIT, *1883, PASTEL ON PAPER, 17 ¾ X 12 ⅝", MUSÉE NATIONAL D'ART MODERNE, CNAC GEORGES POMPIDOU, PARIS, D 1*

Michelangelo and Leonardo to Eugène Devéria, Joseph Nicholas Robert-Fleury, and Horace Vernet.[5] Since the *Cours* were initially done for the use of Beaux-Arts students, they could be found in many of the ateliers where Valadon accompanied her working mother, or where she herself posed after 1880. However, it was the posters that offered to the public, and particularly to Valadon, the greatest connection to an art whose commercialism did not vitiate its quality. They were often signed by outstanding artists like Toulouse-Lautrec, Chéret, or Willette.[6]

It was not until ten years after she started to draw that Valadon decided that some of her works were worth keeping. Among them was an auto-portrait, dated 1883 and boldly signed on the upper left side: Suzanne Valadon. The pastel, done when the artist was eighteen, was the first of a series of self-images, the last one painted in 1931, when she was sixty-six. In all of them the artist displays a decisive objectivity.

A respect for traditional balance and harmony characterizes the first *Self-Portrait*. The work shows the conventionalism found in academic painting with its simple broad forms outlined in dark blue, stressing the importance of linear drawing. The colors are evenly applied and smoothly graduated. The portrait presents Valadon in three-quarter profile, set against a mottled blue-green background somewhat reminiscent of those seen in David's early 1790's portraits.[7] The unity of the composition is enhanced by a limited use of colors that include variations of blue, green, and earthy yellow-browns.

Ingres, whom Valadon admired, thought that "the accessories in a painting play a role similar to that of the confidants in a tragedy."[8] But there are no accessories, no "props," in *Self-Portrait* that might offer clues to the sitter's personality or function. Valadon does not place herself in front of her easel, holding a palette, as do many illustrious women artists, from Vigée Lebrun[9] to Frida Kahlo.[10] The austerity of the composition is maintained. Only the model's head and shoulders are seen, standing out against a background in which the source of light is undetermined. The viewer's eye is drawn to the grave and intense image whose cool delicacy is softened by the graduated shades of surrounding blues. The bold asymmetry of the composition and the fluidity of color point to the skill of an experienced draftsman. Only the stiffness of the sitter's pose and the uneven treatment of forms and volumes reminds us that the portrait is the work of a young artist who has not yet fully mastered technique.

Because of her lack of technical background, Valadon is likely to have consulted teaching manuals or looked at engravings to resolve some of her procedural difficulties. For example, in the portrait, her right ear is delicately rendered, and its sinuous volutes skillfully heightened with red and blue dots; but it appears oversized on a woman's head. It is probable that Valadon was inspired by an image in which the sitter's proportions were larger than hers and that she neglected to adjust the scale to her own smaller size. The modeling of the head is equally questionable. The central hair part rises too sharply and gives the illusion of an elongated skull.

In spite of these minor errors, the *Self-Portrait* is an extraordinary technical and psychological achievement and contains some traits that foretell the originality and audacity of the artist's later compositions. The sitter's off-center location in the lower left corner of the work is as unusual as it is effective. Was this unorthodox placement a result of the artist's inexperience, or was it calculated? This asym-

metry was certainly not inspired by any academic work. Neither was it much utilized in contemporary art, even by the unconventional Impressionists, whose works, particularly those of Renoir,[11] Valadon had seen. The model's placement at the edge of the pastel divides the composition into two oblique sections. A vast expanse of blank space surrounds Valadon and generates a psychological void that isolates her from the rest of the world. Was the rendering of this feeling of isolation intentional? The effect may have been subconscious, yet it reflects the loneliness of Valadon's young years.

If the artist's draftsmanship appears uneven at times, the strength and individuality of the *Self-Portrait* are unquestionable. Valadon aimed at, and succeeded in, offering the viewer more than a physical likeness. She exposed the salient traits of her personality. Although the regular features, the small straight nose, and the sinuous mouth reveal her delicate loveliness, it is her determination, uncompromising spirit, and resilience that dominate an image that Georgel called "imperious and austere."[12] Valadon's motto, "One must be hard with oneself,"[13] is reflected in the set jaw, the defiant expression and the unflinching gaze. Yet a hint of her youthful vulnerability softens the severity of the image.

In this first work, any artifice or conventionality, and even any justified self-interest, have been rejected in favor of the purity of line and stylistic audacity that were to become Valadon's trademarks.

There is no doubt that Valadon was exposed to the street posters, laughed at the newspaper cartoons, and was aware of the reproductions in drawing manuals. Undoubtedly, some of their elements influenced her art and shaped her vision. Liberated from tradition by her autodidactism, unencumbered by the social and artistic prejudices of more privileged social classes, she could appreciate and learn from a commercial art born of a popular tradition. Her paintings, and particularly her portraits, have sometimes been seen as "plebeian,"[14] and even vulgar. However, Valadon came from a proletarian background and painted those who lived around her. If some of her representations stem from the images she saw on street walls or in inexpensive local papers, they are logical manifestations of the essential roots of her art.

Valadon believed that "painting was the most difficult [medium] in which to reach greatness."[15] She worked for thirteen years on her oils before she showed them. The wait was worthwhile when one sees her early *Portrait of Eric Satie* (fig. 2). The musician, who was to be called "The Father of Modern Music," met Suzanne Valadon at the Auberge du Clou, a boisterous and inexpensive nightclub, where he played the piano. An eccentric and penniless bohemian, Satie affected a top hat, a flowing lavaliere, and wore a pince-nez. His room in 6 rue Cortot was next door to Valadon's, with whom he had a six-month liaison.[16] The affair began on January 14, 1893, and Satie proposed marriage that same night. He immediately became obsessed with the artist, whom he called his "Biqui," writing impassioned notes about "her whole being, lovely eyes, gentle hands, and tiny feet."[17] Valadon did Satie's portrait and gave it to him, while the musician did hers, which he kept. The two works hung together and were found after Satie's death in his room at Arceuil.

The fickle Valadon soon ended the romance with Satie, leaving him with "nothing but an icy loneliness that fills the head with emptiness and the heart with sadness."[18]

The *Portrait of Eric Satie* is a small work with a height double that of its length, but it

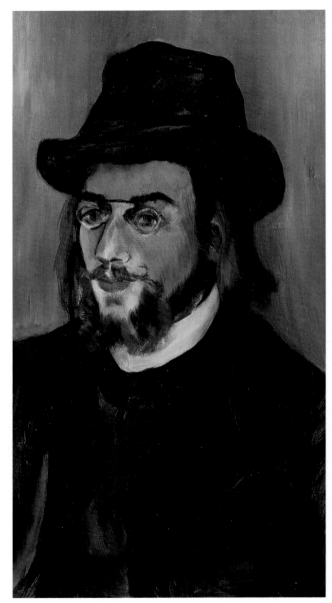

Fig. 2 Portrait of Eric Satie, *1892–93, oil on canvas, 16 1/8 x 8 5/8",*
Musée National d'Art Moderne, CNAC Georges Pompidou, Paris, P 2

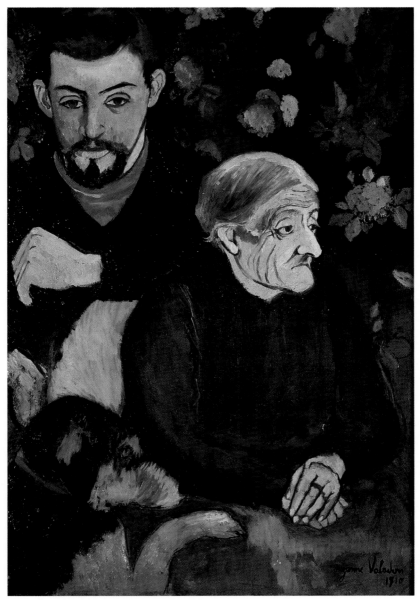

FIG. 3 GRANDMOTHER AND GRANDSON, *1910, OIL ON CARDBOARD, 27⅛ X 19⅝", MUSÉE NATIONAL D'ART MODERNE, CNAC GEORGES POMPIDOU, PARIS, P 39*

achieves a monumentality far beyond its actual size. The oil's unusual dimensions accentuate the sitter's elongated appearance. An abrupt cropping seems to amputate his arms, while his tall hat emphasizes the verticality of the image. The canvas is divided into two squares: the lower one shows Satie's black-clothed bust, and the upper part forms the background, painted in a striated blue-green that sets off the face and dark hat. The head constitutes the focus of the work and is conventionally placed in the center of the composition. It seems to stand upon a light oval pedestal, which is actually the white shirt collar. There are no clues to Satie's character other than those read in the facial details. A decisive and stubbornly fixed glance, sensual red lips, unconventional waxed mustache, and the pince-nez project a personality conscious of and unafraid of its own originality. Satie was twenty-six when the portrait was done, and his lively complexion and taut features stress the youthfulness of the face to such an extent that the skimpy beard appears fake.

The linearity of the image, where every contour is imprisoned in black outlines, is contrasted with the treatment of the visage. Valadon has modeled the features solely with layered patches of color, a Cezannesque technique that she continued to use throughout her career.[19]

The portrait of Satie possesses a monumentality and physicality found in the works of such renowned portraitists as Degas and Toulouse-Lautrec. By filling three-quarters of the canvas's surface with Satie's image, Valadon gives him an overwhelming presence. The musician seems to advance toward the spectator, an illusion created by the receding quality of the pale background. The life radiating from the painting takes its source from the vibrancy of the colors. Large areas of velvety black sparkle with elusive blue-green accents, and Satie's red cheekbones set off his startlingly blue eyes, outlined by the pince-nez rims. Although the portrait was done at the beginning of Valadon's idyll with Satie, passion did not abate her impartiality. Her assessment of her lover reveals a methodical frankness close to brutality. If she has rendered his powerful yet sensitive presence, she has not hidden an aloofness and judgmental quality that sets him apart. He stands alone, towering over the viewer, his strength as well as his weakness captured by Valadon's impartial brush.

Although stamped with Valadon's personality, the *Portrait of Eric Satie* points to several interacting influences—the strength and overwhelming presence of the image evoke the immediacy and sobriety seen in many of Toulouse-Lautrec's posters, his *Aristide Bruand*[20] in particular. Valadon's choice of few but indicative traits gives to the representation a caricatural economy that brings it close to the tradition of the Montmartre satirists.

Valadon seems to have lost her taste for portraiture during the two decades following the *Portrait of Eric Satie*. Not until 1910 did she resume her former interest and pursue it with a new and challenging style.

The 1910 *Grandmother and Grandson* (fig. 3) illustrates the artist's first attempt at group portraiture. It also marks the time when she asserts her personal style under the influence of her lover, André Utter, her son's friend and contemporary, who was twenty-one years her junior. She had met the young man, also a painter, in 1909, and shortly after left her wealthy husband, Paul Mousis, with whom she had increasing difficulties, since he could no longer tolerate the progressive degradation of his stepson, Maurice.

A complete departure from traditional

portraiture, *Grandmother and Grandson* contains an extraordinary mixture of style that includes references to contemporary painters, nineteenth-century Japanese woodcut artists, and primitive masters. Assembling members of her small family circle, Valadon has placed on a crowded background her seventy-year-old mother, her twenty-seven-year-old son, and the family dog, Pierrot. The three figures form a pyramidal structure. Perhaps inspired by ancient art, Valadon has ignored the traditional laws of perspective and given her sitters sizes reflecting their hierarchic importance. A gigantic Maurice towers over the group, his head the apex of the pyramid, his Byzantine Christ-like features inscrutable. Maman Madeleine, who sits on a stool below him, offers a blatant contrast to her grandson's regal handsomeness. Witchlike in appearance, toothless and devastatingly wrinkled, she nevertheless maintains the quiet and resigned dignity seen in old women whose entire life has been spent in hard work. The two sitters' aloofness is shared by that of the dog, who places his paw on the grandmother's lap, his eyes as vacuous as hers.

The dark clothing of both figures melts into the reddish-brown background that a busy floral pattern enriches. The sitter's pale faces seem to "pop out" from their somber garments and become decorative elements as randomly placed as the flowers in the wallpaper.

The composition is powerfully constructed with a linearity that reminds us that Valadon drew long before she painted. In this work she shows submission to several influences. Part of the style can be linked to the primitive masters. The presentation of the sitters recalls that of the donors in Jean Fouquet's diptychs. The grandmother's face reflects a humility and intensity often present in Cranach's portraits.

The most striking effect of Valadon's severe composition is a disconcerting repetition of curvatures. Shaping the sitters' forms, they are echoed in the background by a rhythmic floral pattern that evokes Gauguin's style. This device, borrowed from Synthetism, contrasts strongly with the figures' stylization, whereas the abrupt cropping recalls Japanese woodcut techniques. However, the apparent disjunction of styles is not incongruous. On the contrary, Valadon's unorthodox treatment enriches the painting with an original and unique quality.

Although every inch of the painting's surface has been compulsively covered with paint, suggesting a "horror vacui,"[21] it is Valadon's ultimate simplicity of concept that dominates the composition. Her love of dramatic contrasts and decorative forms does not draw the viewer away from the painting's essential concern, that is, the evocation of two human beings, linked by blood ties but whose unique common factor is their alienation. Their bodies seem to overlap, but they actually do not touch, nor do they face in the same direction. Utrillo looks at the viewer, his unfocused eyes betraying his inner turmoil. A child alcoholic and a diagnosed schizophrenic at sixteen, Valadon's son, by 1910, had been treated in several mental institutions. His grandmother, who raised him, deliberately turns away from him in the picture. The dog's head is parallel to hers, the woman and the dog staring in the same direction, away from Maurice.

To evoke the nature of human presence, Valadon uses simple and understated means, such as a gesture or a glance. The grandmother's crossed hands translate her resignation; Utrillo's lifeless eyes suggest his mental problems. With the conciseness and strength that one finds in Cézanne's portraits, Valadon has brought the old woman and her grandson to life with her own

sparse but effective visual tools — powerful drawing, heavy contours, and a suggestion of Expressionistic color.

Valadon did not envision herself as a portraitist in the traditional sense. She was never interested in duplicating the models' physical likenesses. But the likeness she conjured in this painting is deeper than a physical one, since it is the sitters' souls that she captures with as much patience as interest.

Grandmother and Grandson was followed by several other group portraits that dealt with members of the artist's family. In 1914, she painted *Family Portrait*,[22] in which she also included herself and André Utter, whom she had just married. Utter's mother and two sisters modeled for Valadon several times, individually or together. Valadon had an unceasing fascination with family structure. With the magic of her images she tried, throughout her life, to recreate the roots she had missed in childhood. Among her numerous family portraits is *Marie Coca and Gilberte* (fig. 4), done in 1913. It is a large painting of Valadon's niece and grandniece.[23] In this work, Marie Coca is enthroned on a gigantic arm chair, the back of which rises fanlike above her. At her feet, the child sits on a stuffed cushion, a small doll in her lap. As in *Grandmother and Grandson*, the group forms a pyramidal structure with Marie Coca's head as its apex. Although the sitters' poses are informal, their clothing is not. Both wear their "Sunday best," and the child shows off her immaculate white bow, lace collar, and small string of beads. In this painting, Valadon had abandoned the two-dimensionalty and absolute flatness so striking in her previous family portraits. She has emphasized a sense of volume, weight, and depth. Three grounds are indicated: the child and doll are placed in the foreground, while the armchair

occupied by the mother links the middle ground to the background. An additional feeling of space is created with the diagonal floor planks, meticulously drawn according to conventional perspective. The excessive linearity of the style is softened by a diffuse greenish light that permeates the entire composition without obscuring the contours. Valadon's robust outlines encircle and define the shape of each sitter and each object. The minute details of the decor reflect an uncompromising desire to render reality in its most tedious aspects. The accents of a lace collar and the mother's tiny loop earring testify to a sense of observation that involves more than casual interest.

Marie Coca and Gilberte marks a new step in Valadon's stylistic evolution. The artist now eliminates the compulsively filled backgrounds used in her previous group portraits and allows her sitters greater "breathing space." Although she is, at times, still seduced by such decorative devices as the armchair's floral pattern, she uses them sparingly, thus more effectively. The flower-covered fabric, confined to a small area, is a sophisticated touch. However, the artist has not totally lost interest in rhythmic patterns and broad compositional movements. The subtle impression of curvatures that begins with the half-circle of the chair back continues in Marie Coca's rounded open arms, and it is repeated in the body shapes of the child and the doll. This progressive reduction of figures nested within each other evokes the series of papier-mâché Russian doll sets in which each body becomes the receptacle of a smaller one, which, in turn, houses a more reduced form.

The pyramidal shape of this group creates a slightly off-center structure that is balanced on the right side by a small table supporting two vases containing flowers and holly. The sitters

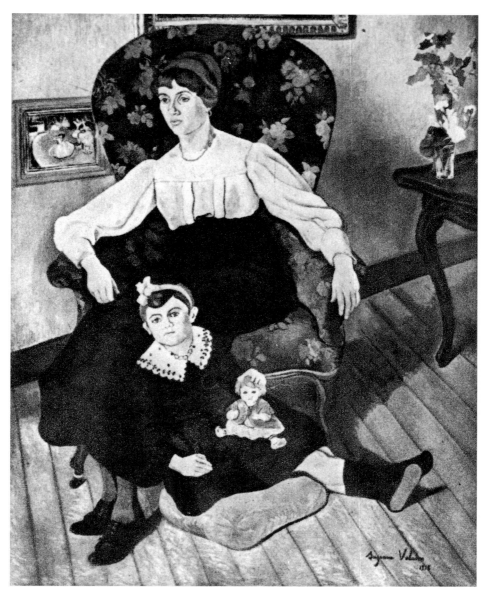

Fig. 4 Marie Coca and Gilberte, *1913, oil on canvas, 51⅛ x 69⅛", Musée des Beaux Arts de Lyon, France, P 42*

display a certain elegance in contrast to the banality of the decor. Its few pieces of furniture were commonplace in modest apartments at the time. Valadon has chosen this unsophisticated setting to present an homage to Degas. One can see, on the left side of the background wall, a painting of dancers, executed in the Impressionist's style. This picture, decorating an unsophisticated bourgeois interior, offers, besides its artistic reference, a rare example of Valadon's imaginative spirit. The presence of this work *à la* Degas in this otherwise pedestrian setting is both unexpected and touching. The edge of another painting, abruptly cut off above the lower frame, appears above the armchair.

The overall green light in *Marie Coca and Gilberte* tones down the painting's hues, less vivid than those seen in the previous portraits. But Valadon's love for saturated colors erupts in the unexpected accents of a coral necklace and the bright red of the holly berries. The blue of the mother's skirt is skillfully contrasted with the stark white of her shirt and the child's collar and bow. The scaled-down shades of Gilberte's blue dress are echoed in the lighter tones of the doll's clothing. The rich material of the stool offers a discreet touch of gray and pink.

In *Marie Coca and Gilberte*, Valadon starts to use more subtle effects, and her unity of style contrasts with the varied treatments combined in her previous works. Harmony prevails in the pictorial form and psychological mood of the work. The artist's taste for parallel curving lines now creates a soothing rhythm. Although mother and daughter do not have any physical or visual contact, the woman's body appears to shelter the child's, who, in turn, extends a protective hand over the doll's head. The two sitters are no longer victims of the alienation suffered by the members of previous family portraits. Marie Coca

and Gilberte become part of a silent communion of maternal love.

In this work, Valadon has abandoned the busy surfaces seen in her former portraits, and the details are limited to few key elements. Only the essential is captured and this austerity transcends the banality of the scene to give it a heroic nature. The static quality of the two sitters, frozen in a pedestrian setting, elevates them to the status of icons. As she did in *Grandmother and Grandson*, Valadon presents Marie Coca and Gilberte with the abbreviated simplicity seen in medieval devotional paintings where the saints and donors are portrayed with a similar quest for verisimilitude. A particular religious painting comes to mind: could Valadon's pyramidal grouping of mother, daughter and doll-child, with its evocation of successive generations, be an overt reference to Leonardo's *Saint Anne, Virgin and Child*?[24]

The Musée des Beaux Arts, Lyon, purchased *Marie Coca and Gilberte* from the artist in 1935. The great statesman and friend of Valadon, Edouard Herriot, Lyon's mayor at the time, was responsible for this acquisition.

Valadon painted Marie Coca alone twice, in 1903 and 1926. Gilberte remained one of the artist's favorite models and appeared in the 1921–22 and 1934 *Gilberte* portraits.[25]

Gustave Coquiot, a talented art critic and successful writer (who became an art dealer in 1916), advised his readers not to pose for Valadon if they longed for "a pleasant and attractive portrait." He predicted: "….the artist will exaggerate your peculiarities, inflate your jowls, or, on the contrary, diminish the size of your chest."[26] Actually, written in 1923, this came as a late admonition, since Valadon had painted Coquiot's portrait and that of his wife, Mauricia, eight years earlier. Valadon's talent for capturing

a model's character can be appreciated at its best in *Portrait of Madame Coquiot* (fig.5). With a lucid pictorial intelligence, the artist caught the woman's flamboyant personality as well as her lack of distinction. These characteristics have been translated with the help of Expressionist colors and contours. The artist's intuitive understanding of the sitter's essence results in a representation that is painfully truthful, decisively pedestrian, but eminently memorable. It also represents yet another step in Valadon's evolution as a portraitist.

The *Portrait of Madame Coquiot* offers a perfect illustration of her husband's warning. Neither "pleasant nor attractive," the painting presents a model whose luxuriant beauty will soon be overripe. Madame Coquiot's towering presence appears almost threatening, the size of her massive but still firm body echoing what might be a considerable ego, her self-confidence bordering on arrogance. However, the woman is endowed with unquestionable authority and a magnificent physicality. Her image dominates the composition, occupying over a third of the canvas, stretching from the lower to the upper edge. The monumental figure is frozen in the immobility seen in the members of Valadon's family portraits. The painter has exaggerated the thickness of the waist, the bulk of the breasts, the artificiality of the pose. Madame Coquiot seems to stand on stage, her statuesque silhouette erect, her defiant head raised against a chocolate-colored panel. Her large body, seemingly poured into a tight, striped sheath, seems compressed between a printed curtain on the right and a gigantic bouquet of gladiolas and lilies on the left. The full blossoms of the flowers are on the edge of decay and the tallest lily stands parallel to the woman's face. The imminent fading of her beauty is suggested by the autumnal coloring of the entire composition. The abstract pattern of the drapery echoes the yellow, rust, and burnt orange hues of the flowers.

Valadon has combined two different styles: the painterly technique used to reproduce the drapery's design stands in contrast to the linear treatment of the floral arrangement painted with brush strokes as minute as Brueghel's.

Mauricia Coquiot's elegant black-striped dress is artfully low-cut, its lavishly embroidered bodice held by small straps that cut the vast expanse of pearly flesh. The head is surprisingly tiny and the face is beautiful, its chiseled features those of a much younger and smaller person. An unexpected touch is that of the woman's small mustache.[27]

Valadon has transcribed with an uncompromising realism the nuances of her model's personality. They are expressed by the defiant toss of the head, the tensely clenched fingers, the proud display of bare flesh. She has caught the peacock-like attitude of Madame Coquiot and the stubborn look of her eyes. We face the portrait of a woman whose power stems from her beauty as well as her social position.[28] Valadon has intuitively perceived, however, that Madame Coquiot's roots were undistinguished, and the heavy hands and wrists and massive arms betray her "plebeian" origins. But the artist has granted her an arresting and memorable beauty that stems precisely from her solid and healthy proletarian background and gives her an earthy substance. The sitter's unpolished and ripe attractiveness has been transcribed joyfully by Valadon, whose pleasure in painting Madame Coquiot is easily perceived. The artist's ultimate satisfaction with her task and with her model has a palpable quality that elevates both sitter and audience.

In the daring portrait of Mauricia Coquiot,

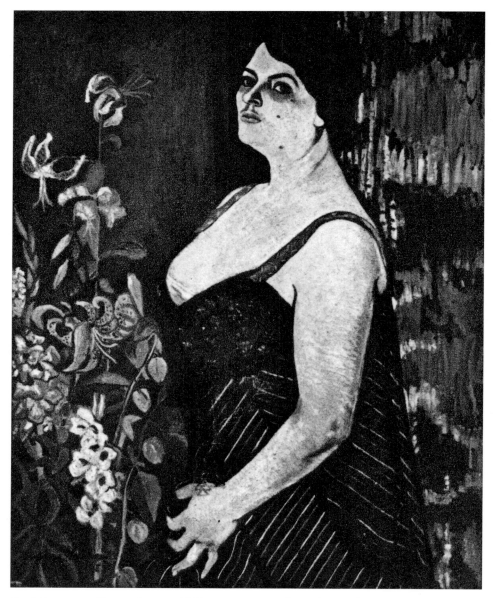

FIG. 5 PORTRAIT OF MADAME COQUIOT, *1915, OIL ON CANVAS, 36⅜ x 51⅛", MUSÉE DE MENTON, FRANCE, P 66*

Valadon borrowed once again from Toulouse-Lautrec and the Montmartre caricaturists. But this work possesses a worldliness foreign to the excessive simplicity found in the *Portrait of Eric Satie*, where neither background nor accessories were shown. It is those elements that contribute to further defining the sitter's personality. The added symbolism of a "vanitas" hinted in the fading flowers and the autumnal hues, brings a new level of intellectual and stylistic sophistication to this powerful and candid portrait.

It is interesting to note that Gustave Coquiot was not offended by the frankness displayed in his wife's portrait or in his own.[29] He remained Valadon's truest admirer. His sole grievance was that the artist was wasting her time "defending her genius against the endless jokes and the stupidity of amateurs."[30]

By 1922, Suzanne Valadon seemed to have achieved promising success in both her private life and her career. Her husband, André Utter, wounded in battle in 1917, had returned safely to Paris at the end of World War I. The couple lived at 12 rue Cortot with Maman Madeleine and Maurice Utrillo, who, in spite of his recurring bouts with alcoholism, had captured the interest of a few serious dealers and was given a large exhibition at the Lepoutre Gallery in 1919. That year Valadon exhibited at the Berthe Weil and John Levy galleries. In the following year she was elected a member of the Salon d'Automne, where her works had been shown since 1909. In 1922, Robert Rey published the first monograph dedicated to her art.[31] Four years later, she would sign a contract with the Bernheim Jeune Gallery.[32]

The "Trio Maudit's" tumultuous life never ceased to attract scandal and gossip. The artists led an extravagant life mostly supported by the sale of Utrillo's works, the latter's finances being managed by Utter. To live up to their new prosperity, Valadon hired Lily Walton, an English housekeeper, to run the household, where numerous cats and dogs coexisted more harmoniously than the humans in the family. Lily Walton remained for a few years at 12 rue Cortot, where Valadon painted her portrait in 1922.

The *Portrait of Miss Lily Walton* (fig. 6) presents a new aspect of Valadon's portraiture. It could also be viewed as a genre painting, and it was followed the same year by a few others done in a similar style.[33] In her earlier works, the artist had expressed her sitters' personalities through their physicality. Their images often occupied the major portion of the works, where the background was compulsively filled with decorative patterns. In the Lily Walton portrait she now includes in the decor additional keys to the model's personality. Although the surroundings in which Lily Walton is shown are not her own, but those of the Utter family, the artist has endowed the room's sparse furniture with a solid elegance that is communicated to the housekeeper herself. The composition is divided into two pie-shaped sides, and Miss Walton occupies the left side of the foreground. There is no middle ground, and the background containing only furniture, seems almost to be a later addition to the canvas. This reminds one of Degas' *Woman with Chrysanthemums*, where the greater part of the painting is taken up by a huge bouquet.[34]

Lily Walton sits casually but primly and holds on her lap Valadon's cat, Raminou, whom she painted seven times between 1919 and 1920. His importance exceeds that of a mere pet, and he is given equal footing with the housekeeper. A russet ribbon around his neck, he curls on Walton's lap, the central focus of the composition.

Once more, Valadon has constructed a pyramid-like structure that reaches its peak with her sitter's head. However, the dimensions of the housekeeper's body are not scaled to those of the background furniture. To paint her sitter, Valadon had to stand in the lower right side of the room, but she had to position herself in the lower left side to observe the furnishings. Walton is viewed at closer range than the furniture. These different vantage points could have destroyed the balance of the composition, but Valadon has restored it with the sharply ascending lines of the chest of drawers that introduce a new dimension to the space of the painting.

In the earlier portraits done at her studio in the rue Cortot, Valadon did not include any of the decor. However, she shows Lily Walton sitting in a tastefully furnished room. Elegance appears to be the quality the artist wanted to evoke. Walton's demure stature, the fineness of her chiseled features, suggest a refinement that is echoed by the Empire armchair and antique chest. Furthermore, Valadon, by calling the housekeeper "Miss Lily Walton" has stressed the importance of her British nationality, perhaps thinking it added an element of distinction.

The details chosen to personalize the decor have been carefully selected and rendered. The carvings on the wood frame of the armchair are faithfully reproduced, and the marble top of the chest supports an eclectic display of objects ranging from a cheap doll that could long ago have been won at a fair, to a potted pink azalea and an oval painted box. The blond wood of the dresser, the mottled aspect of its marble top, and the gleaming brass handles have been carefully observed and reproduced.

The few discrepancies in size found in the composition are not accidental, as were those in Valadon's early works, and they are handled skillfully. The massiveness of the housekeeper's figure, for instance, has been tempered by the presence on her lap of Raminou, whose frame is perfectly scaled to Walton's, and the pale surface of a draped curtain behind her lessens the impact of her oversized bulk.

The simplicity of the sitter's white shirt and dark jumper contribute to the mood of quiet elegance to which Valadon has added a feeling of protective warmth. The cat rests happily and safely in the shelter of Lily Walton's arms. The peaceful harmony of the painting is strengthened by Valadon's choice of colors. The earth hues that the artist loved glow in accents of russets and yellows. Walton's somber garment is enriched by the stripes of Raminou's coat and the gold of his eyes echoed in the housekeeper's hair.

If this picture can be viewed as a genre painting, it also can be seen as a double portrait of the housekeeper and her cat. Raminou is shown in a frontal view, and he makes eye contact with the viewer with the same intensity expressed by Lily Walton. Valadon loved animals and often granted them a wisdom that she sometimes denied her human sitters.[35]

Her *Portrait of Miss Lily Walton* and most of the other portraits done in 1922 show an indulgence Valadon seldom extended to her female sitters. They point also to Valadon's new interest in further developing her model's identity with the help of the accessories that personalized their living quarters. It reveals the new-found conviction that the sitters cannot be separated from the home in which they live, the furniture and objects they select, the flowers they pick, and the pets they love.[36]

In 1932, Valadon did a last portrait of her husband, *André Utter and His Dogs* (fig. 7). This work was her final attempt at a large composition, and it shows a radical departure from the

style of her previous portraits. Until then, Valadon had always painted her sitters indoors, whereas *André Utter and His Dogs* was done "en plein air." The sitter is shown on the grounds of the castle of Saint Bernard, located in the Beaujolais country, near Villefranche sur Saône. Valadon had first come to this region to visit Utter when he was wounded during World War I. In 1923, both returned on a sentimental pilgrimage to Bellevue, the small town where Utter had been hospitalized. There, they heard of a thirteenth-century castle for sale and bought it on a characteristic impulse, despite its dilapidated condition.[37] Only the tower, the central part of the building, was habitable, and separate studios were laid out to accommodate each member of the "Trio." The couple sent for Maurice, and the family lived there happily for a short time. However, the castle's picturesque drawbridge and the moat did not compensate for the crumbling walls, the humidity in summer, and the lack of heat in winter.

At first, the artists enthusiastically painted the beautiful grounds, although Maurice continued to turn out views of Montmartre streets. The Utters lavishly entertained their Parisian friends, but Valadon missed Montmartre. Upon their return to the capital, the chasm between the jealous Valadon and her much younger husband deepened, and their violent arguments became more frequent. Furthermore, Utter, a capable but unsuccessful artist, was frustrated by Utrillo's artistic recognition, even though the whole family benefited from its financial rewards. By 1932, the couple's relationship had completely disintegrated. Valadon had moved from the rue Cortot in 1926 to live with her son in a house purchased by the Bernheim Jeune Gallery at the nearby 12 avenue Junot, also in Montmartre.

Utter remained in the studio at the rue Cortot but traveled frequently to Saint Bernard, to which he had a strong attachment. Valadon, aware of his feelings, thought it would be fitting to paint her husband in his favorite environment. Since 1923 she had done several paintings of the castle, the surrounding countryside, and the nearby village. Her visits, however, had become rarer. She traveled to Saint Bernard in 1931, when she painted the castle, and the village church. The 1932 landscape of Saint Bernard, a view from the park, and the portrait of Utter mark her last visit. She was never to return to Saint Bernard.

The year 1932 was distinguished by a most important Valadon retrospective of sixty-five works at the Georges Petit Gallery. The exhibition catalogue contained an enthusiastic foreword written by Edouard Herriot, the French premier at the time. Valadon also had an exhibition of drawings and etchings at the Galerie Au Portique, and, at the same time, a joint show with Utrillo and Utter at the Moos Gallery in Geneva. In addition, the engraver Daragnès published a deluxe edition of her graphic works. Regardless of favorable press reviews, Valadon sold very few works during that year.

Valadon suffered deeply as a result of her difficult relationship with Utter, whose infidelities were notorious. Although the couple lived apart, she still loved him passionately, but her jealousy erupted into violent scenes that exasperated Utter. She had turned sixty-seven, and their twenty-one year age difference became increasingly noticeable.

In the bucolic and peaceful *André Utter and His Dogs*, none of the bitterness between the artists surfaces. Utter is shown sitting informally on a tree trunk laid on the grass. His two dogs rest at his feet. The X formed by his body is accentuated by the vertical lines of his cane,

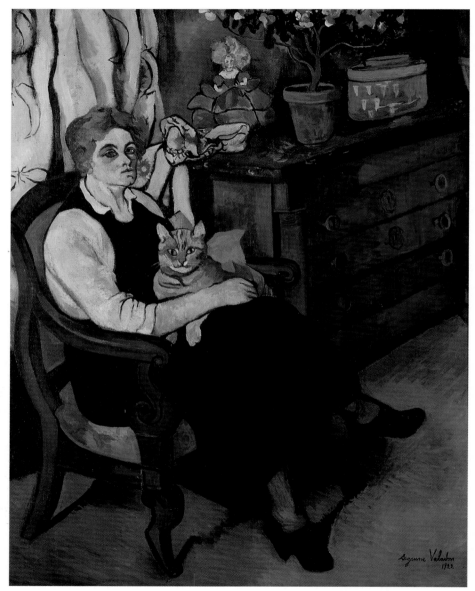

Fig. 6 Portrait of Miss Lily Walton, *1922,* oil on canvas, *39 ³/₈ x 31 ⁷/₈",* Musée National d'Art Moderne, *CNAC* Georges Pompidou, *Paris P 244*

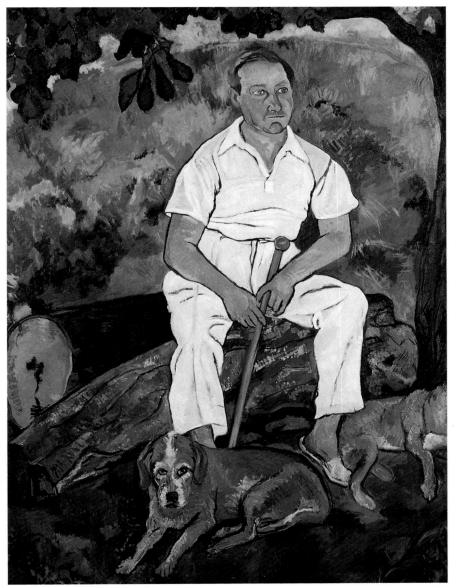

FIG. 7 ANDRÉ UTTER AND HIS DOGS, *1932, OIL ON CANVAS, 64 ⅛ X 51 ⅜", PRIVATE COLLECTION, P 429*

perhaps planted there as a phallic symbol by the still rowdy Valadon.

It is hard to determine the role in which Valadon wanted to cast her husband. Was it that of a gentleman farmer? Did she think that posing him on the peaceful ground of a medieval castle would confer on him the "class" of Miss Walton? Utter's white trousers and short-sleeved shirt, however, would be more likely seen on a tennis court than in an ancestral park, and his carriage somehow lacks the distinction of that of the English housekeeper.

Utter sits under a chestnut tree, protected by the solace of its green leaves. At the age of forty-six, he still retains some youthful aspects, his reddish complexion lighting up a plump face whose fullness has been trimmed down.[38] Utter's bright blue eyes and his cleft chin are rendered with loving care. Valadon has endowed him with the frontality and directness of some of Ingres' male models,[39] but none of their decisiveness.

Valadon has used a light palette. She has toned down the brightness of the summer hues and spotted the green grass and nearby bushes with touches of gold, announcing a forthcoming fall. Perhaps Utter's slight paunch and receding hairline are reminders of the not-too-distant autumn of his own life.

With a conventionalism rarely seen in her previous portraits, Valadon has divided this composition into three parts. The sitter's figure occupies the large middle ground, the dogs lie in the foreground, and rolling hills constitute the background. The picture follows the tradition established by such nineteenth-century English painters as Gainsborough and Reynolds. However, in these artists' portraits the landscape plays a romantic but unimportant role, while in Valadon's hands it has far more significance, serving to signify the sitter's personality. The Saint Bernard countryside is there to inform the viewer of its crucial role in Utter's life, and nature takes on an increased meaning as one realizes how rarely it appears in Valadon's portraits.

Several influences emerge in *André Utter and His Dogs*. The handling of the tree on the left side of the composition is inspired by Cézanne. It links the foreground to the background of the scene, as one of the branches stretches across the picture to unify its space.

There are some unusual effects suggested by Japanese nineteenth-century woodcuts, such as the abrupt cropping, which amputates half of the large tree trunk and cuts off part of the sleeping dog's head.

Again there is a duality in the technique of the composition. Linearity triumphs in the treatment of Utter's figure, of the dogs, the chestnut tree, and the leaves. Each of the forms is edged with dark outlines. On the other hand, the grounds, the vegetation, and the skimpy stretch of sky are done in a painterly manner. The green of the hills is spotted with diffuse yellow marks invaded occasionally by dark brown blemishes. Certain areas of the background seem so uncharacteristically blurry that they could suggest an unfinished state. Possibly putting the last touches on her estranged husband's portrait became so emotionally taxing for Valadon that she could not complete it. Showing him alone on the property they so enthusiastically bought together nine years earlier must have been particularly painful.

It is interesting to note that even if Valadon gave Utter the appearance of a forty-six-year-old man, his relative youth could not have brought him much pleasure. His pensive and grave expression does not translate any of the happiness appropriate to a gentleman farmer sitting

on a clear day on the lovely grounds of his beloved "château." Actually, the only contented sitters are the two dogs resting happily at their master's feet.

This was the last picture Valadon did of Utter, and it marks the artist's physical, emotional, and artistic decline. Her health had deteriorated, and she was distressed over Utrillo's hopeless alcoholism. But if Valadon had lost her "joie de vivre," she had not lost her lucidity. In 1931, shortly before she started *André Utter and His Dogs* she did a final and cruel *Self-Portrait with Bare Breasts* (Chapter III, fig. 3), where she appears nude to the waist, her breasts sagging, her masklike features tense and drawn. Nevertheless, her head is held high in proud acceptance of her age and of her life.

Two years before her death, Suzanne Valadon did the *Portrait of Geneviève Camax-Zoegger* (fig. 8). Her sitter was the daughter of Marie-Anne Camax-Zoegger, the dynamic president of the Fédération des Artistes Modernes (F.A.M.), a woman's organization she herself started in 1931. Two years later she persuaded Valadon to enter F.A.M.'s yearly exhibition, which included the works of "the most talented and representative artists of the time."[40] Valadon agreed to do so and continued to exhibit with the group until 1938, the year of her death and the disintegration of F.A.M.[41]

At the time Valadon did her portrait, Geneviève Camax-Zoegger was studying at both the Ecole du Louvre and the Beaux Arts, the former being the most prestigious French art history university, while the latter offered extensive art training at the ateliers of famous conservative artists. Geneviève Camax-Zoegger, whose married name is Barrez, received her doctorate in 1947 and became a well-known painter. Valadon often met the young woman, who visited her with her mother. Charmed by her blond beauty and sweet disposition, Valadon decided to paint her portrait and exhibit it at the forthcoming 1937 F.A.M. show in which women artists from several European countries participated.[42] At the end of the show, Valadon generously gave the portrait to the sitter as a token of her affection.

Geneviève Barrez recalls that she only posed for her portrait for three sessions. Each took place at the avenue Junot atelier and lasted for three hours.[43] For the past few years, Valadon had been plagued with uremia and diabetes. She had lost much of her former energy and had considerably reduced her artistic activity. Barrez believes that, although her portrait is signed and dated at the upper left corner of the canvas, it is "incomplete." She suspects that the artist was too tired to spend on the work the considerable amount of time she devoted to her other portraits. However, the quality of the picture is outstanding, and its "unfinished" state allows us an insight into Valadon's working methods.

Unlike many of her contemporaries, Valadon did not size her canvasses herself. She purchased them already primed with a substance made of diluted glue in which a whitener gave the surface a cream color. On the prepared canvas Valadon did a preliminary drawing with either a regular or an extra-thin charcoal.[44] She occasionally did studies for her large compositions, but seldom for her portraits. She did not make a sketch for Camax-Zoegger's portrait.

In spite of Valadon's physical and emotional condition, the *Portrait of Geneviève Camax-Zoegger* is one of her most charming works. It celebrates youth, spring, and happiness. A pink light seems to float over the composition, where graduated tones of rose and red are discreetly enhanced by touches of complementary greens.

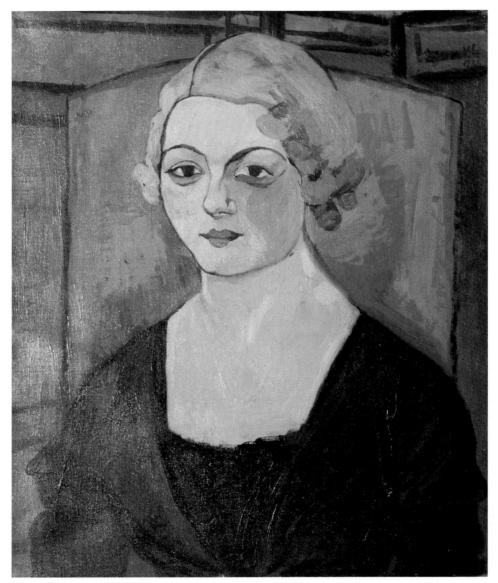

FIG. 8 PORTRAIT OF GENEVIÈVE CAMAX-ZOEGGER, *1936, OIL ON CANVAS, 21⅝ x 17¾",* COLLECTION GENEVIÈVE BARREZ, PARIS, *P 464*

The portrait is bust-length, and the sitter is shown frontally. Her head and shoulders are framed by the back of a dusty pink armchair, often seen in the background of Valadon's late portraits.[45] The model's face is framed by the chair upholstery, and the warmth of its pink hue tints her pale complexion with a delicate blush. The location of the chair establishes the composition's background and contributes to an illusion of three-dimensional space. In a gray background, touched by an occasional green spot, the vertical lines of an indistinguishable piece of furniture further extends the depth of the picture.

In this painting, as in many of her portraits, the artist has not used a unified technique. With a precision that reveals her taste for linear treatment, she has defined the forms and imprisoned the colors within the boundaries of her outlines. However, the strong definition of line lends the sitter a somewhat static appearance.

On the other hand, Valadon turned to a Cézannesque technique when she built the relief of the model's face and recreated its different planes through a juxtaposition of layered accents of color. This modeling through tonal changes can best be observed in the rough aspect of the unfinished left cheek, where unblended applications of several red touches contrast with the smooth and delicate handling of the finished right side of the face.

Valadon has used the complementary greens sparingly but effectively. The velvety black of the sitter's bodice flickers with green spots that surface from the underlying coat of paint. Green streaks emerge from under the girl's blond hair and are woven into the rose material of the armchair. In spite of a limited scale of hues, Valadon has created dramatic contrasts that enliven an understated composition. For example, the play of the model's pearly décolletage against the black-green darkness of the garment is an unexpected accent not unlike those seen in Manet's early portraits.

Most of Valadon's works show a surface compulsively covered with paint. In Camax-Zoegger's portrait, traces of the cream primer appear in tiny touches that are never visible in any of Valadon's "finished" paintings. Many of her brush strokes are clearly imprinted, particularly in the large surface of the chair material, giving it a mottled aspect. Similar effects are obtained more smoothly in other paintings through patient variations of tones.

Valadon was very fond of Geneviève Camax-Zoegger, whom she nicknamed "Angelique" because of her angel-like disposition and her ethereal beauty.[46] In this portrait, the artist tried to convey to the viewer her sitter's delicate loveliness. It is through the expressive means of a muted color and a delicate handling of lines and volumes that the artist evokes the young woman's distinguished but discreet personality, whose contrast with her own buoyant nature fascinated her. Valadon could be pitiless in her representations, particularly those of women. In the *Portrait of Geneviève Camax-Zoegger*, she has shown unusual restraint in a composition where Expressionist pastel colors triumph over linearity and where the sitter's essence is best suggested through the rose light that bathes the composition. The heart-shaped visage reflects a physical loveliness and serene personality. It is interesting to note that Valadon shows as much talent in a portrait where distinction and refinement are the essential qualities as in her lucid and brash representations of the more "plebeian" women of her neighborhood.

Paul Pétridès was an enterprising art dealer who met Suzanne Valadon through André Utter.

Pétridès was born in Cyprus in 1901, the last of thirteen children. The family was poor and struggling, and Paul, who had been trained as a tailor, immigrated to Paris in 1927, determined to find fame and fortune. Introduced to the world of art by his French wife, Pétridès developed an unerring eye for quality as well as an aggressive business sense. In 1929 he opened a small gallery. There, he assembled a stable of young artists to whom he added Utrillo by offering him a custom-made blue suit in exchange for a gouache. He charmed Valadon, who decided to paint his portrait. Pétridès, in his memoirs, relates the circumstances of his sittings at the avenue Junot.[47] He arrived punctually at nine o'clock the morning of the first sitting. Valadon proceeded to clean her brushes and feed her pets for two hours, beginning to paint at eleven, but stopping at noon. She repeated her routine for the next few days until Pétridès decided one morning to arrive at eleven o'clock. He was confronted by an irate Valadon, who reproached him for his lateness and demanded his punctual presence at nine for the remaining sessions. When Valadon finally announced the portrait was finished, she asked the dealer to return the following day to watch her sign her work, a gesture she believed to be the "ultimate reward for an artist."[48] It took her three hours to sign and date the oil, but Pétridès thought that the portrait was "magnificent" and kept it in his private collection.

The *Portrait of Paul Pétridès* (fig. 9) is worthy of the dealer's enthusiasm and ranks among Valadon's finest achievements for its stylistic qualities as well as for its acute assessment of Pétridès' personality. The dealer's image, spread over two-thirds of the canvas, is powerful without being overwhelming. The forms are simple and the palette limited to scaled-down reds and grays. Pétridès' head is traditionally placed at the center of the composition, thus providing its focus. It is set against the dusty pink upholstery of Valadon's favorite armchair. Its surface stretches almost to the top of the painting, and reduces the background to a few inches of gray, striped with the oblique dark edges of a beam.

Valadon is more concerned with the linear quality of the work than with color. Although the modeling of the face is achieved through layers of paint and spots of red over large areas of modulated whites, color plays a secondary role, and the hues are used for their descriptive rather than expressive qualities. The composition is structured by a severe assemblage of black outlines that define forms and volumes. Pétridès' features are evoked with vigorous strokes of a dark charcoal that draw the wide-open eyes punctuated with arched brows, assert the strong nose, and encircle the generous mouth shaded by a hint of mustache.

It is clear that Valadon was impressed by the dealer's determination and perhaps attracted by his youth, as she had been by Utter's. She presents Pétridès as a strong and determined man who faces life and its challenges with audacity. His strength and his youth are both reflected in the set jaw, the taut skin darkened by a "five o'clock shadow," and the deep cleft chin. But it is also the portrait of a stylish man. His elegance is reflected in such minute details as the small pin that adorns the dark gray tie, the elaborately cut suit lapels, and the emerging edges of a breast-pocket handkerchief. However, the strict tailoring of the suit and the crispness of the starched white shirt identify him as a businessman conscious of current fashion rather than as a "dandy."

The *Portrait of Paul Pétridès* is among the last five paintings by Valadon—done between

1934 and 1937. It testifies to her quintessential mastery of portraiture. In this work, the artist eliminates all superfluous elements and expresses her sitter's personality solely through the traits of his physiognomy and a few sartorial details. She now discards the decorative devices often found in her earlier pictures and describes her model's physicality with the rigor of a Photorealist artist. Ultimately she transcends verisimilitude with an impalpable element that grants it the gift of life. Her simplicity hides a psychological perception as keen as but less cruel than Toulouse-Lautrec's. In the *Portrait of Paul Pétridès*, Valadon's style has finally come of age. By carefully rejecting the seduction of expressionist color, by abstracting her forms into a basic reductivity, she has achieved a monumentality that is the measure of her talent.

The most important quality of all of Valadon's portraits is an unrelenting search for the sitter's essence. To recreate a person's individuality, the artist has looked at varied and eclectic sources. From the fifteenth-century masters she borrowed the monumental simplicity of the figures; from nineteenth-century Japanese woodcutters, their two-dimensionality. She emulated Degas' immediacy, Toulouse-Lautrec's caricatural shorthand, and Gauguin's mastery of color. And yet, all these elements are ultimately blended and transcended into Valadon's eminently personal style of portraiture.

"I think that I will keep my originality while I copy," was one of Ingres' remarks.[49] Valadon's portraits undoubtedly offer the most glorious illustrations of this great painter's statement.

A few paintings done during Valadon's mature period defy categorization. Among them are *Blue Room* (fig. 10) and *Woman with White Stockings* (fig. 11).

Is the *Blue Room* a portrait? A genre scene? Perhaps a "clothed" nude? While the work could be any one of these, it is fairer to define it as a synthesis of all of them. Regardless of its definition, it stands as one of the most sophisticated and successful of Valadon's paintings. Exhibited at the 1923 Salon d'Automne, it was purchased three years later by the Musée du Jeu de Paume.

The *Blue Room* is Valadon's quintessential representation of a female figure in an interior. While it gives us an excellent likeness of the model, the image transcends the limitations of pure portraiture. Its realist depiction of a type of crude female suggests Toulouse-Lautrec's brothel inmates. The woman's indecorous pose, the cigarette dangling from her lips, and the loose garment that reveals her massive but voluptuous form, proclaim a sexual availability. Yet, in spite of her apparent permissiveness, she possesses an individuality and self-assurance that are foreign to Toulouse-Lautrec's prostitutes. Neither does she show the defiance of Manet's *Olympia*,[50] a well-known courtesan. For Olympia's black cat—a blatant sex symbol—Valadon has substituted a small stack of books, perhaps a pointer to an intellectualism unknown to Manet's courtesan, but required for Valadon's modern woman.

The model lies nonchalantly on a sofa, well aware of her sensuality. But even if she reclines in the pose of Ingres' *Odalisque*, she shows none of the latter's passivity. No longer an "object" of desire, she holds the power of her own decision. There is an element of drama to the scene. The woman seems displayed as on a stage that two side curtains define.

The composition is vigorously handled. It illustrates the best of the artist's mature style and strikes a harmonious balance between the

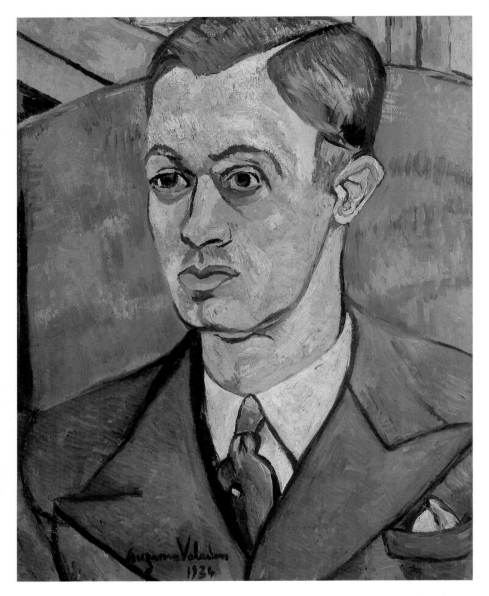

FIG. 9 PORTRAIT OF PAUL PÉTRIDÈS, *1934, OIL ON CANVAS, 24⅞ x 16¼", COLLECTION PAUL PÉTRIDÈS, PARIS, P 462*

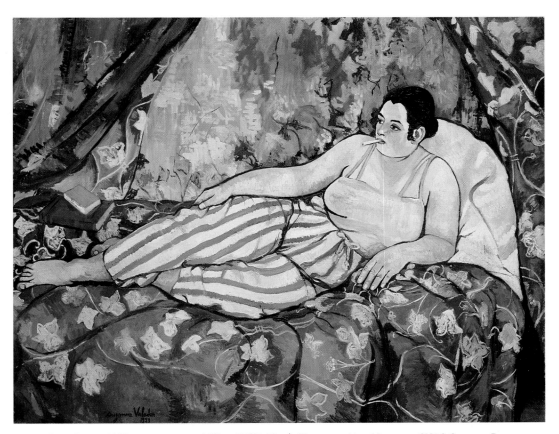

FIG. 10 BLUE ROOM, *1923, OIL ON CANVAS, 35 ⁷/₁₆ X 45 ⁵/₈", MUSÉE NATIONAL D'ART MODERNE, CNAC GEORGES POMPIDOU, PARIS, P 275*

model's figure and the decor surrounding it. It is evenly divided into the three classical grounds, to which space Valadon has given a shallow treatment. The rich array of decorative motifs and the contrasting designs of the printed fabrics, recall the overdecorated backgrounds of the artist's early family portraits. However, it is no longer Valadon's "horror vacui" that dictates an overwhelming wealth of patterns but a deliberate wish to assemble a variety of floral and geometrical forms that are subtly unified by the dominant blue that bathes the whole composition. Its cool values enhance the warm accents of the woman's pink shirt and the red and brownish-green hues of the books. It is through the saturation of this blue that Valadon alleviates a visual discomfort created by the complexity and abundance of decorative surfaces. She has skillfully used the horizontality of the model's striped pants to stretch the composition laterally and negate a claustrophobic reaction to the busy floral design of the sofa. The green of the stripes echoed in the leaves of the coverlet strengthens the composition's unity. The pinks, ochers, and whites of the central background material are repeated in the tones of the woman's flesh and of her shirt.

The interest of the work is heightened by subtle contrasts. While Valadon has kept a severe linearism in a composition where every contour is darkly outlined, the rigor of her style is softened by a large background space treated in a painterly manner. The brutal naturalism of the figure is tempered by the lavish splendor of the room setting. The *Blue Room*'s originality erupts in the opposition between the carefully delineated volumes of the woman's body and the oriental bazaar-like jumble of the room.

The model in a similar but reversed pose

is seen in a work done in 1912 titled *The Future Unveiled*.[51] In *Blue Room*, Valadon has succeeded in updating the formula of the centuries-old Odalisque theme on a stylistic as well as a conceptual basis. Discarding clichés of feminine beauty and refinement, she has demonstrated that vulgarity can achieve magnificence when treated by an artist of unusual talent and vision.

Done a year later than *Blue Room*, *Woman with White Stockings* presents a similar ambiguity regarding a subject matter that vacillates between portraiture and genre scene. It also contains an element of eroticism rarely found in Valadon's works.

A woman sits sideways on an armchair, circling her right knee with both arms. She seems to be turning away from the viewer. She occupies the Empire chair used in Lily Walton's portrait, but unlike the prim and proper posture of the English housekeeper, her pose is both indecorous and provocative.

As the title indicates, the woman wears white stockings that she has rolled down to just above her knees, displaying a generous portion of her fleshy thighs. Her bright red pumps match the vermilion of an abbreviated tunic embroidered with a pattern of white arabesques that reveals her snowy underpants edged with lace. The chair is upholstered with a red moiré fabric a shade lighter than that of the garment. The background of midnight blue shows traces of the verdigris covering the floor, and its darkness sets up the vividness of the large red areas. These reds burst into the composition without disrupting it. Actually, it is the extensive use of this color that becomes the work's unifying factor.

The impact created by the dominating reds is heightened by the inclusion of large

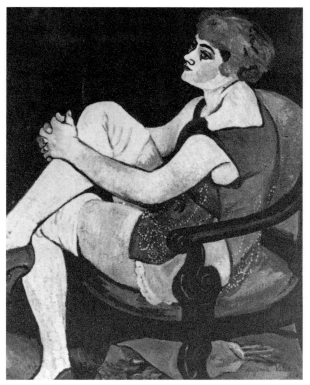

FIG. 11 WOMAN WITH WHITE STOCKINGS, *1924, OIL ON CANVAS, 28³/₄ X 23⁵/₈", MUSÉE DE MENTON, FRANCE, P 293*

areas of white treated with tonal variations. Shades of blue appear in the fabric of the lingerie, while flesh-like strokes of pink and ocher give life to the stockings.

The sitter, a massive and mature woman, is heavily and awkwardly made up, and an uneven spot of rouge appears slapped on her left cheek. She has dyed her hair a shade of orange that does not succeed in hiding the dark roots. However, in spite of her provocative pose and the vulgar overuse of cosmetics, the sitter's face, with its chiseled nose and large dark eyes, reveals a certain fineness unexpected in a person of her bulk. Valadon has, once more, imprisoned all contours in dark outlines. They give autonomy to each shape but instill in the scene a static quality further maintained by the large surfaces of unmodulated hues. However, the artist has woven a pattern of interacting lines that infuse the composition with dynamic strength. A circular movement starts with the round contours of the chair's seat, arm, and back. Their circumvolutions are echoed in the

parallel curves of the model's thighs and arms, thus creating a circle with the elbow marking the center. The sitter's head has been treated as a separate smaller sphere with no connection to the rest of the body.

The composition possesses an extraordinary unity and compactness, and it constitutes one of the best examples of Valadon's mature style. The artist has succeeded in establishing her own individuality while still referring to outside sources. From Renoir she recalls the "neither black nor white"[52] edict. She borrows from Gauguin her severe cloisonism, and from the Nabis, her pure colors. But these elements, unskillfully used in her early paintings, are now integrated into a personal visual language, and its end result is "pure Valadon."

The artist has introduced into this work a shade of eroticism that is rare in her œuvre. Women's open sexuality is a recurring theme in many of her compositions, particularly in her nudes. But these images speak of healthy, unabated sensuality. The message of the *Woman with White Stockings* is more equivocal. Her state of partial undress, the half-rolled stockings exposing her robust thighs, her sexually inviting pose contribute to creating a suggestively erotic climate. The woman's vulgarity, her disabused ennui, place her within the ranks of common prostitutes so dear to Degas and Toulouse-Lautrec. Undoubtedly, she is one of the "girls" blatantly displaying her charms. Her occupation is further confirmed by the presence under the armchair of a discarded bouquet reminiscent of the flowers presented by a black servant to Manet's *Olympia*. The overwhelming presence of red, a color proverbially associated with carnal love, strengthens the sitter's erotic message.

But the *Woman with White Stockings* does not display Olympia's impudence nor the passive resignation of Toulouse-Lautrec's brothel inmates. Valadon neither judges nor condemns— she exposes. She paints the servant girls, the florists, the housewives, and sometimes the local prostitutes of her neighborhood. If the *Woman with White Stockings* sends an erotic message to the viewer, it is because sex and eroticism are as much a part of her trade as sweat is part of Courbet's working peasants' lives.

Woman with White Stockings belongs to Valadon's saga on women of her time and social class. Stripped of moral pretentiousness, free of social prejudice, her account has the ring of truth and the visage of Montmartre modernity.

1. She seems to have interrupted painting portraits only from 1893 to 1910.

2. For a more detailed analysis of nineteenth-century portraiture, see Frank Whitford, *Expressionist Portraits*, London, 1987, pp. 16–20.

3. The meeting took place in 1886. See *Van Gogh à Paris*, Catalogue, Musée d'Orsay, Paris, 1986, p. 31.

4. At the time of the 1889 Exposition Universelle in Paris, Gauguin, with the help of his friend Schuffenecker, exhibited seven of his works on the walls of the Café Volpini, near the site of the Exhibition.

5. These were academic painters who taught at the Beaux-Arts in the later part of the nineteenth century.

6. For a more detailed discussion of the development of posters, see Anne-Claude Lelieur and Raymond Bacholet, *Célébrités à l'Affiche*, Lausanne, 1989.

7. See, for example, J. L. David, *Portrait of Madame Trudaine*, c.1790, oil, Musée du Louvre, Paris, and *Autoportrait*, 1794, oil, Musée du Louvre, Paris.

8. Daniel Ternoi, *Monsieur Ingres, peintre d'histoire: Tout l'œuvre peint de Ingres*, Paris, 1971, preface. In the classical plays of Corneille and Racine, the confidant's role is to enable the main character to reveal the intricate details of the plot.

9. Vigée Lebrun, *Self-Portrait*, 1790, Uffizi, Florence.

10. Frida Kahlo, *Self-Portrait with a Portrait of Dr. Farill*, 1951, Private collection.

11. Valadon had posed for Renoir but not yet met Degas who did some asymmetrical compositions (See footnote 34).

12. See *Suzanne Valadon*, Musée National d'Art Moderne, CNAC Georges Pompidou, Paris, 1967, catalogue entry #88.

13. *Suzanne Valadon ou l'absolu*.

14. Bernard Dorival, *Etapes de la peinture française contemporaine*, Paris, 1943, p. 218.

15. *Suzanne Valadon ou l'absolu*.

16. The affair between Valadon and Satie is fully discussed in Rollo H. Myer, *Eric Satie*, London, 1984.

17. Quoted from Satie's letter, March 11, 1893, Archives of the Musée National d'Art Moderne, CNAC Georges Pompidou, Paris, Vol C.2, 122–128.

18. Ibid.

19. This will be discussed later in this chapter.

20. *Aristide Bruand at the Ambassadeurs*, 1892, Musée Toulouse-Lautrec, Albi, France. Bruand is shown wearing a black hat and large red scarf.

21. "Horror vacui," a Latin term meaning "aversion to empty spaces." When applied to a canvas it means a compulsively covered surface.

22. *Family Portrait*, 1912, oil on canvas, 38⅛ x 28¾", private collection, Nice, P 38.

23. Marie Coca was the daughter of the artist's half-sister Marie-Emilienne. She is shown with her own daughter, Gilberte. Both mother and daughter appear in the *Abandoned Doll*, 1921, The National Museum of Women in the Arts, Washington, D.C., the Halloday Collection, P 219.

24. *Saint Anne, Virgin and Child*, Leonardo, c. 1507, Musée du Louvre, Paris.

25. This last work was erroneously titled and sold as *Self-Portrait*. It is now identified as *Portrait of Gilberte*, 1934, private collection, unlisted in Pétridès'catalogue raisonné.

26. Coquiot, p. 166.

27. A small mustache also decorates the upper lip of other dark haired beauties. See, for example, Frida Kahlo, *Self-Portrait with Loose Hair*, 1947, private collection.

28. Gustave Coquiot achieved considerable importance as a writer and art critic.

29. *Portrait of Gustave Coquiot*, c. 1915, oil on canvas, 15¾ x 13", Musée des Beaux Arts, Alger, P 65. In this portrait Coquiot himself displays "oversized jowls" and an unbecoming underchin.

30. Coquiot, p. 167.

31. Robert Rey, *Suzanne Valadon*, Paris, 1922.

32. Berthe Weil, John Levy, and Bernheim Jeune were important galleries at the time.

33. Portraits of *Madame Levy, Madame Kars, Madame Zamaron*, and *Germaine Utter*.

34. Degas, *Woman with Chrysanthemums*, 1858–1865, Metropolitan Museum of Art, New York. This painting was begun in 1858 as a still life of flowers. In 1865, Degas added the figure of a woman on the left.

35. For an interesting discussion of the role of cats in portraiture, see F. Foucard and P. Rosenberg, *Le chat dans la palette*, Paris, n.d.

36. Walton worked for Valadon for a number of years. Even if she did not decorate the room herself, its decor could be viewed as her own.

37. This purchase was possible because Utter was managing the sale of Utrillo's works, which commanded very high prices.

38. An earlier study for this same portrait shows the "large jowls" feared by Gustave Coquiot.

39. See, for example, Ingres' *Portrait of Monsieur Bertin*, 1832, Musée du Louvre, Paris.

40. As quoted in *Comedia*, February 1932.

41. F.A.M. ceased to function at the beginning of World War II and did not resume its activities after the war ended.

42. *Les Femmes Artistes d'Europe exposent au Jeu de Paume*, Musée des Ecoles Etrangéres, Paris, France.

43. Interview with Geneviève Barrez, August 13, 1979.

44. Interview with Barrez, September 20, 1992.

45. Portraits of: *Paul Pétridès*, 1934, P 462; *Madame Pétridès*, 1937, P 463; *Gilberte*, 1934, unlisted in Pétridès' catalogue raisonné.

46. Interview with Geneviève Barrez, September 9, 1992.

47. Paul Pétridès, *Ma chance et ma reussite*, Paris, 1978, pp. 72–74.

48. Ibid., p. 79

49. *Ingres raconté par lui-méme et ses amis*, edited by P. Cailler, Lausanne, n.d.

50. Manet, *Olympia*, 1863, Musée d'Orsay, Paris. In this work, the nude woman reclines on a crumpled day bed, a black cat at her feet, her servant presenting her with a large bouquet.

51. *The Future Unveiled*, 1912, oil on canvas, 24¾ x 51⅛", Musée du Petit Palais, Geneva, Switzerland, P 145.

52. Interpreted by Dr. Robert Le Masle as a reference to Renoir, who explained to Valadon that pure black or white did not exist. *Suzanne Valadon*, 1967, p. 30.

CHAPTER III

NUDES

*Let us remain committed to the art of the nude
and the cult of the Woman which we see as the
glorious communion of all that is great with all
that is beautiful. Let us be grateful and loyal to
the painters and sculptors who do not abandon
this august theme and are aware that Nature is
nothing but a temple built to Woman . . .*

—LE NU AU SALON DE 1888, *INTRODUCTION*

Despite its grandiose pomposity, this quotation is a hypocritical expression of the concept of French nineteenth-century official art, where a woman's beauty had to conform to a predetermined image and the representations of her nude body submitted to limiting conventions.[1] Valadon extended

the range of this previously restricted subject with daring innovations and broke with centuries-old traditions by stripping female nudity of its erotic message. Furthermore, by boldly displaying nude male models, she introduced a drastically new iconography previously forbidden to women artists.

The human figure was of particular significance to Suzanne Valadon. As a model, it was by revealing her body that she earned her living and supported her family. She knew it played a critical factor in the art of the painters for whom she posed. She realized it was the only subject to which she had constant access, but she soon understood that she did not have to be confined to her own likeness. The images of her family and friends were there for her to paint.

She started to work with single nudes shown in stark settings. As her skills increased, she undertook more ambitious projects that involved multiple figures, often seen in a landscape. Ultimately her nudes transcended the field of pure representation to become the vehicles of a personalized interpretation dictated by a feminine point of view. Not only did she find the courage to appropriate prohibited subjects, but she had the vision to create a new art form — the nude self-portrait.

Valadon was most fascinated by portraiture, but it was in the art of the nude that she worked for the longest time. It was, therefore, inevitable that she would combine these two interests to create nude portraits. Since she also recorded her own image, as most artists do, Valadon left us a series of psychologically revealing auto-images.

In the history of art, the nude self-portrait has been only rarely attempted, particularly by women artists, even those of Valadon's generation. It is unimaginable to think of Berthe Morisot or Mary Cassatt immortalizing themselves in the nude on canvas. Alone among Valadon's contemporaries, Paula Modersohn-Becker did nude self-portraits in 1906, three years before Valadon's.[2]

Valadon painted herself in the nude several times, but there are three oils of particular interest. Dated 1917, 1924, and 1931, respectively, they can be seen as historical documents, and they offer a clinical record of the artist's aging and her subsequent physical deterioration. *Nude with Bare Breasts* (fig. 1) was painted when Valadon was fifty-two, yet it presents the image of a youthful woman. Uncharacteristically, it is a pleasing and peaceful self-portrait in which she appears free of the tensions that are so palpably oppressing in most of her other representations. She is shown full face in this bust-length work, where she occupies a conventional central position. Her unlined visage seems on the brink of a smile, her body utterly relaxed. She could well be sharing a companionable cup of tea with an unseen friend, were she not exposing her breasts, which have lost the firmness of youth and hang over a white, rolled-down garment.

A feeling of peace permeates this well-balanced self-portrait. Unexpectedly, it is a quality of femininity that the artist emphasizes, aided by the curves and rounded contours that dominate the work. There are, however, some puzzling details that challenge, compositionally and conceptionally, the idea of this portrait as a conventional image. In Valadon's time, the symbol of a woman exposing her breasts, except for nursing mothers, was inevitably seen as an offering to male desire. But Valadon's breasts have lost their appealing firmness, and her seminudity is stripped of any expected erotic suggestion. Whereas an occasional glimpse of some partly discarded lingerie—preferably black and

lacy—might offer a seductive allusion, Valadon's rolled-down, unadorned shirt prevents any possible sexual innuendo. Another jarring element is the unattractive cropping of the model's left arm, cut at the wrist with the crude glimpse of a finger on the left hand as if Valadon worked from a photograph taken by an unskilled artist.

In spite of her body's imperfections and the premeditated absence of sex appeal, Valadon presents a serene appearance. She was, at this time, a woman in love. In June of 1917, André Utter was wounded in battle and Valadon had traveled to Meyzieux, in the Saône region near Lyon, to visit him in a military hospital. There she had been reassured about his health as well as his feelings toward her. Furthermore, her professional activities were rewarding. Berthe Weil and the Bernheim Jeune Gallery had given her joint exhibitions with Utrillo and Utter. Life was finally peaceful for Suzanne Valadon.

Done in 1924, *Auto-Portrait* (fig. 2) is the most despairing, the most frightening, and the most implacable picture ever painted by the artist. It is difficult to account for the anger and dismay it evokes in the context of Valadon's personal and professional life at the time. Thanks to the sale of Utrillo's Montmartre cityscapes, the family was enjoying financial abundance. Valadon herself was in her most creative period, doing portraits, nudes, still lifes, and landscapes. She had just signed a contract with Bernheim Jeune, for which occasion the well-known art critic Tabarant had organized a banquet. Critics, journalists, writers, and artists from Valadon's circle had been wined and dined. Francis Carco and the Coquiots mingled with Braque, Derain, Hermine David, Pascin, and the engraver Demétrius Galanis.

Although Valadon's career seemed to flourish,[3] she was far less successful professionally than her son. And, worst of all, she was beginning to experience trouble in her relationship with her young and handsome husband.

The epithet that best describes the 1924 *Auto-Portrait* is violence. Its impact permeates the composition. Valadon, who was fifty-nine at the time, is presented as ageless and almost sexless, her breasts still drooping and now shrunken, her shoulders squared, her features masculinized. The black mass of her hair clings helmet-like to her skull. The composition is somewhat traditional, with her face the focal point of the painting. Valadon is shown frontally, but she directs a malevolent glance to the right. Gone are the equanimity and feminine softness displayed in her 1917 self portrait, *Nude with Bare Breasts*. They have been replaced by unrepressed anger and resentment, directed at either the viewer or, more likely, at Valadon herself.

Visible large brush strokes model Valadon's face with chaotic layers of thick paint darkened with somber hues. Wide strips of color shape the muscular body and strengthen the arms. But the most disturbing factor is Valadon's choice of self-punishment. She turns her image into that of a man and obliterates all traces of prerequisite female softness. Her sole concession to her gender is in the inclusion of a black necklace that looks more like a rope than a string of beads.

The 1931 *Portrait with Bare Breasts* (fig. 3) was painted when Valadon was sixty-six. The anger shown in her 1924 portrait is now replaced by a melancholic resignation paired with an acceptance of fate that gives the work an immense dignity.

Valadon is the first woman artist to record so precisely and mercilessly the progressive damage of time to a female body—her own. This portrait, sometimes seen as pathetic, transcribes faithfully the furrows on her brow, the

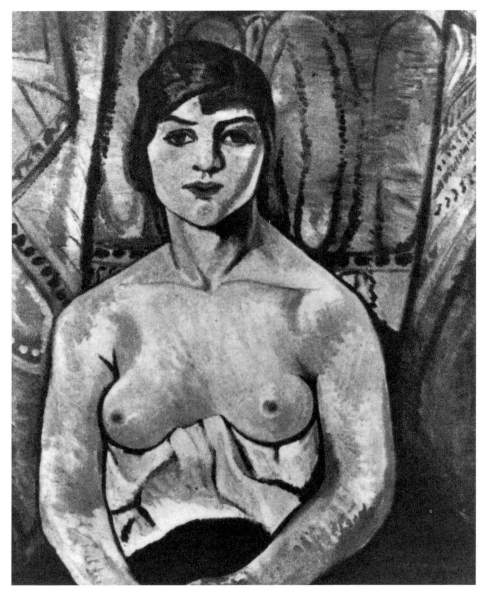

FIG. 1 NUDE WITH BARE BREASTS, *1917, OIL ON CANVAS, 25⅝ x 19⅜", PRIVATE COLLECTION, LAUSANNE, SWITZERLAND, P 73*

slackening of the jowls, as well as the pursed lips and sunken eyes. But in this painting she seems to be reconciled with her condition and gender. She has made up her face and combed her hair. She is placed above the line of sight, and her eyes gaze into the distance with a resigned but enlightened wisdom.

If these three portraits constitute a unique documentation of a woman's aging, they also illustrate the artist's concept of the female nude. It is now presented stripped of the sexuality that was its "raison d'être" in France in Valadon's time. With her nude self-portraits she not only created a new art form but endowed it with the importance it deserves.

If Valadon showed an uncommon courage in presenting her realistic nude self-portraits, she was even bolder in daring to paint men in the nude. She was the first French woman to do so in the early twentieth century, and it was not until the 1960s that American women artists like Alice Neel followed Valadon's path in the context of the cultural emancipation of the women's art movement. Although the male nude has always figured in sacred and profane art, it was off limits to women artists, under the hypocritical pretense of gender propriety. It was even believed, in the eighteenth century, that if young women worked with male models, they would lose, if not the flavor of virginity, at least its "sweet perfume."[4] Women did occasionally violate the taboo to attempt male representations, but they were exceptions, and they failed to establish the male academy figure as a permissible art form for female artists—until Valadon imposed her iconoclastic views.

As early as the sixteenth century in Italy, Lavinia Fontana (1552–1614) had attempted to paint the male nude. She became a successful painter of religious and historical scenes in the cultural region of Bologna. Her fame was so extensive that it was complimented by the art writer Carlo Cesare Malvasia.[5] Her works commanded high prices, and she obtained several public and private commissions. As a mother of eleven, she had no lack of models. Overstepping the limitations of portraiture, "she painted many subjects involving numerous figures, even male and female nudes."[6] She was followed by Giulia Lama (c. 1685–after 1735), a Venetian painter whose talented works were assigned to male artists such as Jan Liss and G. B. Tiepolo, until recent scholarship attributed the paintings to her. She left over two hundred drawings that included "shocking studies of the male nude."[7]

Born of Polish parents in Berlin, Anna Dorothea Liszewska-Therbusch (1721–1782) moved to Paris in 1765 and was elected a member of the French Academy. She undertook a portrait of the encyclopedist, Diderot, who was to be shown with bare shoulders. Since her model was posing fully clothed, the artist had difficulty painting his neck. A helpful Diderot decided to "strip" and has given this account of his experience: "I was nude, completely nude. She painted me and we chatted with a simplicity and an innocence worthy of earlier times."[8] Diderot's portrait is known only from an engraving, but a smaller version, also done by Liszewska-Therbusch, is in Berlin.[9]

Her lack of access to nude models seriously handicapped the courageous Angelica Kauffman (1741–1807) in her execution of large-scale historical paintings, themselves considered unsuitable for women. However, Kauffman persevered in this field, and when she settled in London she became one of the first women elected to the British Royal Academy. Her fame was such that when she

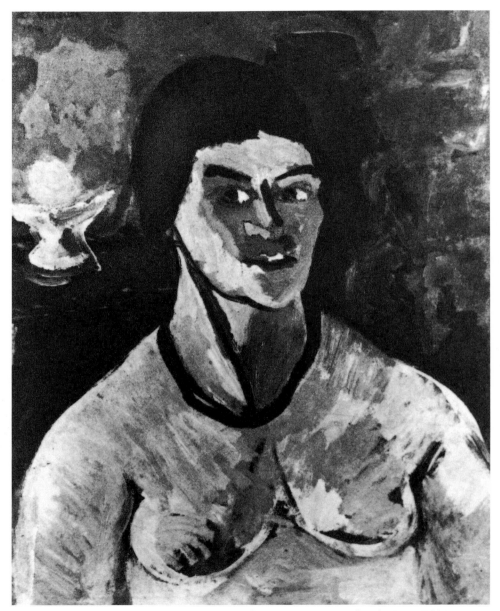

FIG. 2 AUTOPORTRAIT, *1924*, OIL ON CANVAS, *15 ⅝ x 19 ¾"*, COLLECTION PAUL PÉTRIDÈS, PARIS, P *299*

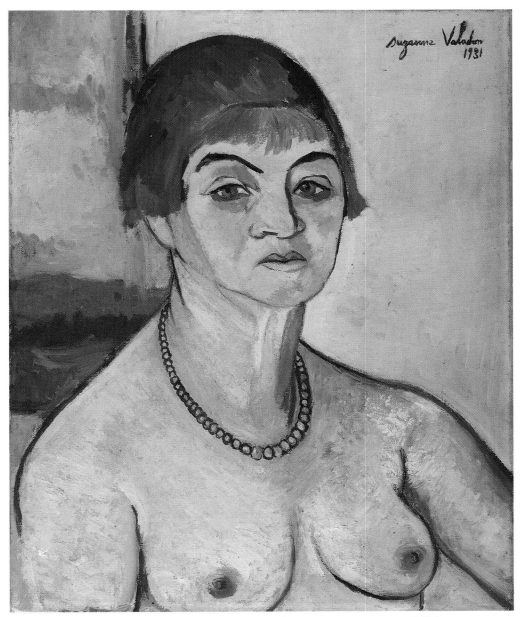

FIG. 3 PORTRAIT WITH BARE BREASTS, *1931, OIL ON CANVAS, 18⅛ X 15", PRIVATE COLLECTION, P 427*

died the sculptor Canova planned for her an elaborate funeral, modeled after Raphael's.[10]

Valadon only painted nude male bodies between 1909 and 1914, with André Utter as her sole model. She did not, however, represent him casually, as she did her female sitters. The scenes in which Utter appears are historical paintings presented in outdoor settings. The subject matter is either biblical (*Adam and Eve*) or allegorical (*Games, Pastoral Scene, Joy of Living*, and *Casting of the Net*). The artist may have felt that her male nude representations would gain dignity and credence when shown in a heroic context. Utter's departure for the war in 1914 coincides with the date of Valadon's last depiction of the male nude (*Casting of the Net*). Perhaps the problems she encountered by daring to show male genitalia became so overwhelming that she abandoned her ambitious history paintings to restrict her nude representations to women and children.

Valadon's most disruptive appearance on the twentieth-century art scene was marked by the exhibition in the 1920 Salon des Indépendants of her large-scale *Adam and Eve* (fig. 4). However, to be able to show her work, Valadon had to paint a stretch of vine leaves over Adam's genitalia.

Adam and Eve is the first painting done by a woman to represent a man and a woman together in the nude. Valadon has achieved a perfect balance between human figures and landscape. Adam and Eve's "balanced, prosperous and confident" bodies are gloriously nude, according to Kenneth Clark's definition.[11] Valadon has given us her own interpertation of the Garden of Eden before the Fall. The serpent is missing, and the couple share the guilt. Eve holds the apple, but Adam guides her hand in an ambiguous gesture that could signify either denial or encouragement. Both seem "to float above the ground" in a joyful choreography, perhaps inspired by Utter, who once described Valadon as "walking on air."[12] More than a religious painting, the work is a celebration of love where human factors such as the passing of time have been abolished. Valadon and her twenty-three-year-old lover modeled for *Adam and Eve*, and the artist ignored the marks of their age difference. In spite of a realistic depiction that imparts sensual overtones, the scene retains a quality of innocence.

The couple's harmony is echoed in the Arcadian landscape, where the grass is lustrous, the sky blue, and the fruit, even the forbidden kind, is bountiful. There is no doubt that Valadon has remembered Puvis de Chavannes in *Adam and Eve*'s classical poses done in the spirit of the *Sacred Wood*,[13] a work for which Valadon had posed extensively. She recalled later that she had been the model, not only for the women, but also for the young men in the painting.[14] The decorative concern expressed in *Adam and Eve*, the frontal representation of the figures, the flat areas of color and, above all, the harmonious classical proportions of the nudes were pictorial elements used by Puvis and observed by Valadon during the nine years she posed for him.

Valadon had done numerous paintings of her son, but she had never used a mature male model. It was in 1909, when she was forty-four, that Valadon had her first opportunity to paint a man in the nude. In that year she fell in love with Utter and left her husband to live with the younger man. She began to paint him as he painted her—in the nude.[15]

There was another version of *Adam and Eve*, where both figures were shown nude. Only a photograph of the work, taken by Bernés,

Marouteau & Cie, Paris, remains.[16] There are two preliminary drawings in which Adam is nude.[17]

Valadon's interest in the male nude did not lessen after she painted *Adam and Eve*. In 1910, she did two paintings on the theme of the Garden of Eden, *Games* and *Pastoral Scene*,[18] both modeled by Utter and a rejuvenated Valadon. These are ambitious works where the artist has included additional figures in the landscape. In *Games*, Eve is playfully trying to reach a garland that Adam holds above her. In the middle ground, a second couple sits on scattered rocks. The man's genitals are hidden by a white drapery and he extends a protective arm over his companion's shoulders.[19]

In *Pastoral Scene*, Adam still teases Eve with the garland, but the seated male in the middle ground has been eliminated and only the nude back of his companion appears. In the foreground, a reclining woman precariously stretches her leg. This image was undoubtedly inspired by one of Renoir's *Bathers*,[20] for which Valadon posed.[21]

In *Games* and *Pastoral Scene*, Valadon has extended the realm of the landscape so sparingly indicated in *Adam and Eve*. She has opened a large vista of rolling hills that shelter two low-roofed houses. Although these two works reflect Valadon's happy mood, they lack the spontaneity and lyricism that is so appealing in *Adam and Eve*. The figures, particularly the one inspired by Renoir, are stilted, frozen in time. The women are nude but, careful not to offend her viewers, the artist has tactfully presented Utter in profile to conceal his genitals. Valadon has retained her interest in decorative elements, such as the dark outlines around the figures, and stylized shapes borrowed from Gauguin. The balanced composition, inspired by Puvis and seen in *Adam and Eve*, has not been maintained in *Games* and

Pastoral Scene. Valadon's handling of many figures set in a large composition is awkward and lacks the smoothness and harmony present in her less elaborate oils.

The theme of nudes in a landscape is further developed in *Joy of Living* (fig. 5). In an interpretation of the goddess Diana bathing,[22] Valadon now successfully manages to integrate human figures into the landscape. During the second half of the nineteenth century, "plein-air[23]" artists, in particular the Impressionists, started to treat the subject of nudes in landscape scenes in casual and unstructured ways. This newly created art theme was a starting point for subjective visual impressions that offered multiple new iconographic interpretations. Among those is Valadon's *Joy of Living*, which ranks among her most ambitious undertakings. Although the large composition is unmistakably stamped with her personality, memories of Puvis and Gauguin have left their imprint.

Five large nude figures stand in a clearing. Four women are assembled on the left of the composition, each pursuing a different activity, each facing in a different direction. In the right foreground a young man, his arms crossed over his chest, observes the group. The space of the painting is delineated by heavy trees. Their trunks and foliage create a triangular stage that channels the spectator's eyes. There is no discernible source of light, but the front of the young male's body appears to be spotlighted. His slender build and youthful looks are in contrast with the robust maturity of the women's bodies. There is no communication between the bathers, who neither touch nor look at each other. The central figure, the object of the man's attention, is stretching her voluptuous form in a gesture of sensual relaxation. This pose is similar to that of

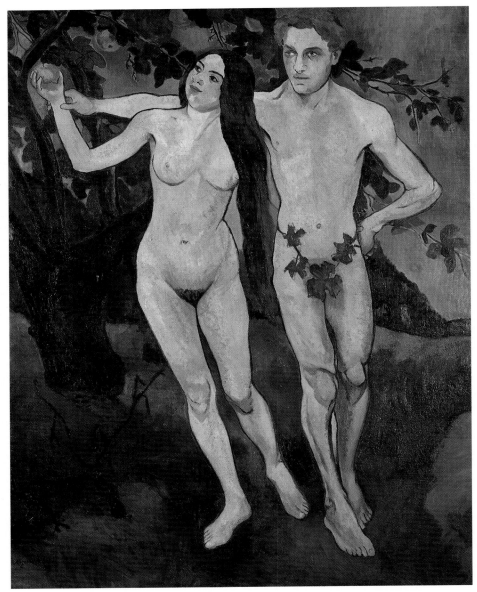

FIG. 4 ADAM AND EVE, *1909,* OIL ON CANVAS, *67 ¾ x 51 ⅝",* MUSÉE NATIONAL D'ART MODERNE, CNAC
GEORGES POMPIDOU, PARIS, *P 23*

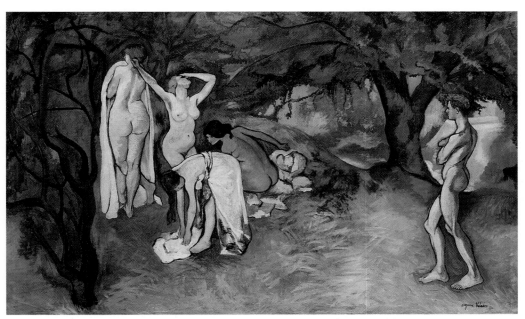

Fig. 5 Joy of Living, *1911, oil on canvas, 48 x 81", Metropolitan Museum of Art, New York, P 29*

the woman on the extreme left side of Matisse's *Bonheur de Vivre*,[24] a work shown at the 1906 Paris Salon des Indépendants, where Valadon began to exhibit in 1911 but had visited earlier.

At this central figure's feet, a dark Gauguinesque girl sits, partly hidden by the half-clothed body of a woman bending down, in a pose inspired by Manet.[25] The figures form a pyramid whose oblique direction is continued by the head of another bather. The latter is isolated as she turns away from the group, her fleshy back as solid as that of the nude seen in Courbet's 1853 *Bathers*.[26] Valadon possibly wanted to illustrate a variety of poses, as her bathers stand, sit, bend, and stretch. Equally emphasized is the alienation of the four women, whose only link originates with the man's gaze.

Many artistic references can be traced in *Joy of Living*. Valadon has not forgotten Puvis' predilection for stable classical composition, the sensual physicality of Courbet, or the exoticism of Gauguin's Tahitian girls. But what she discards is Renoir's concept of woman as an erotic offering to male viewers. Even if Valadon's nudes are unequivocally female, they function independently, unconcerned about the male spectator. Their indifference is Valadon's indifference, and it is best expressed by the gesture of the bather who offers the sight of her solid back to the gaze of the young voyeur. It is Valadon the woman and Valadon the artist who defiantly turn their back on contemporary art restrictions, social convention, and female servitude.

Casting of the Net (fig. 6) is the first known work by a woman that is exclusively devoted to the male nude. André Utter was once more the model for this composition, which shows him in three different sequences of the same movement. He is painted in the nude, but Valadon was careful to hide his genitals behind the twisted ropes

of a net, a coy device that actually draws the spectator's eye to the part of the model's body that is concealed. Regardless of Valadon's reticence about exposing her lover's full anatomy, this painting is an extraordinarily defiant statement, for Valadon reversed the traditional active male, passive female concept and dared to cast a man as an object of desire — her own.

Reverting to academic traditions, she offers an idealistic vision of man in nature, as did Puvis in his monumental compositions. But unlike Puvis, Valadon does not attach a symbolic message to her work. What she expresses is the beauty and harmony of life, encapsulated and reflected in the magnificent athletic body of her companion. The new happiness that the artist experienced between 1909, when she met Utter, and 1914, when he departed for battle in World War I, is translated in the large composition. This euphoric state found its best but last expression in *Casting of the Net*. The work is a pagan hymn in which Valadon has finally assimilated and transcended the influences that marked the start of her career. It is a celebration of love, dominated by Valadon's healthy sensuality. It is brought forth with a primordial realism, unexpectedly rendered through the means of a classical iconography. A stylized Utter stands in triplicate on a reddish rock formation, displaying his muscular anatomy as he goes through the motions of casting his net. With the interest for movement she showed in *Joy of Living*, Valadon has developed the fisherman's gestures in the sequential manner of Muybridge's photography.

Sketches for *Casting of the Net* were done in Corsica, where the artist went on vacation with Utter and Utrillo in 1913. The trio stayed at Belgodère in a local castle thirty miles from Calvi. Valadon did several landscapes there,[27] as well as *Study for a Landscape of Corté*.[28] There

are four pencil sketches of Utter nude, casting a net,[29] and two lateral studies of his body. In the painting the figures are life-size and harmoniously share the foreground of the composition. The left one is shown from the back, holding the net, in an academic pose inspired by Bazille's 1868 painting *Fisherman with a Casting Net.*[30] This painting was exhibited posthumously at the 1910 Salon d'Automne where Valadon herself showed two works.[31] Valadon has brought life to a scene that would appear static were it not for the richness and vibrancy of the colors and the rhythmic movement of the forms. Utter's tanned flesh radiates against the deep blue of the sky and water, and the yellow-green of the rocks and nets. Brightly colored areas glow with the hardness of enamel. The influence of a contemporary Fauve exhibition might have inspired the pure but violent quality of the hues.[32] The rhythm of the figures and the tapestry-like complexity of the background recall Gauguin.

It is obvious that Valadon remembers Puvis and Gauguin. It is certain, as well, that it is her personal style that dominates this work. *Casting of the Net* is a harmonious, traditional, but iconoclastic work. Its monumentality, its reach for classical beauty, must not make us forget the pioneering character of a subject never before attempted: the male nude as seen and shown by a woman artist.

Valadon's interest in the male nude was short-lived, and *Casting of the Net* can be seen as her last attempt in this phase of her work. However, her fascination for female nudes never wavered, and she has left us some of the most novel and challenging interpretations in a field that was, until her arrival, a bastion of male traditionalism.

Since Valadon received no formal training in art, she was free of the limitations of academic teachings. Because of her milieu, she was not subjected to social, intellectual, and personal conventions. Furthermore, her physiological perception of the female body and her experience as a model gave her a particular awareness of the problems encountered when rendering it. These elements played an important role in her interpretation of the nude as well as in her choice of models. For centuries, female nude representations were off limits to women. They remained the domain of men, whose stereotyped images confirmed for their male viewers the superiority of their gender and suggested as well female sexual availability. Women, painted by men for a voyeuristic male audience, were cast in assigned roles of temptresses. Valadon's nudes were presented without the pretext of satisfying either men's desire or the sitter's vanity. They were casually nude as they attended to their bathing or stole a brief moment of leisure. They were nude because nudity was a state that best expressed the basic essence that Valadon aimed to capture.

Her models were her familiars. Apart from her mother, Utter's sisters, and the English housekeeper, whoever crossed the artist's threshold might be asked to disrobe, regardless of age, function, or appearance. Most of her sitters show the rugged body, massive thighs, and fleshy backs associated with Valadon's prototype of female beauty. Their physical presence overwhelms. They are ordinary working women whom Valadon observes with a superficial coldness tinged with involuntary empathy. They attend to their daily lives, with humble gestures that translate with profound simplicity, their chronic lassitude or a fugitive moment of peace. At times, they exude the animal sensuality of Courbet's and Manet's females. It is reality that concerns Valadon, although this reality is not always likable.

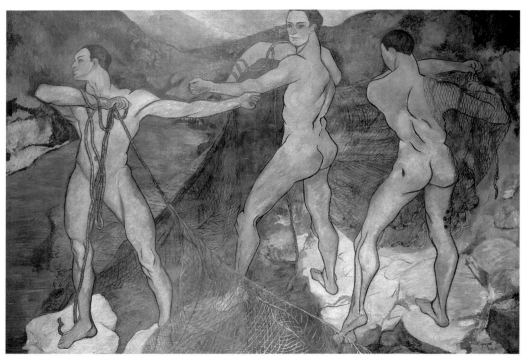

Fig. 6 Casting of the Net, *1914, oil on canvas, 67 ¾ x 51 ⅝", Musée National d'Art Moderne, CNAC Georges Pompidou, Paris, P 55*

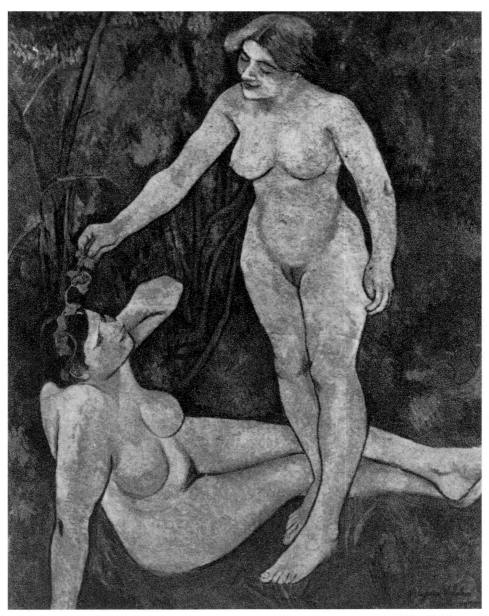

FIG. 7 THE MOON AND THE SUN, *OR* THE BRUNETTE AND THE BLONDE, *1903, OIL ON CANVAS, 39½ x 31⅞",*
COLLECTION *PAUL PÉTRIDÈS, PARIS, P 11*

In 1903, Valadon rendered the first of her large paintings of female nudes. Titled *The Moon and the Sun* by one of her students, it is also called *The Brunette and the Blonde* (fig. 7). It was painted, as a first-state photograph indicates, in the gardens of Luna Park.[33] One of the models was a local charwoman, Catherine.

In an ill-defined landscape, a blonde appears about to crown her companion's dark head with a garland of leaves. The heaviness of the hips and thighs of their voluptuous figures is emphasized by a plunging perspective.

Every form in the composition is outlined in black as if the artist felt the need to define the areas that had to be filled in with color. She has borrowed her severe linear style from the contemporary Montmartre painters who insisted on giving a vigorous definition of forms to their realist works.[34] The monumentality of the figures in the outdoor setting evokes Gauguin, the only artist to whom Valadon claimed an allegiance. In one of her rare stylistic self-evaluations, she confessed to having been "intrigued by Pont Aven techniques,"[35] although she wanted them "applied to Naturalist subjects."[36] But if the decor refers to Gauguin, the woman's gracious offering of a wreath speaks of Puvis' classical compositions. In spite of the figures' nudity, the stiffness of their poses and the awkwardness of the bodies deny the painting any sexual reference. Oblivious of their audience, the women stand by themselves, for their own enjoyment rather than that of male Peeping Toms.

This initial and problematic work on the theme of bathers was followed in 1909 by the far more sophisticated *Neither White nor Black* (fig. 8). Done the year Valadon met Utter, it reflects her newly gained confidence in handling more intricate compositions where she uses color as an autonomous medium. The rigid stylization of *The Moon and the Sun* gives way here to a flow of lines, a rhythmic balance, and a concern for the work as an entity. While Valadon still utilizes strong outlines, these are now of varying colors. The title, *Neither White nor Black,* can be interperted as a reference to Renoir. Valadon told Dr. Le Masle that she had always tried to follow Renoir's precepts, as demonstrated in this particular composition, where black is no longer seen in the contours and white areas have been shaded.[37]

Valadon pursued the theme of bathers in a landscape in large allegories until 1914. She continued to be interested in depicting two nudes together, her increasing assurance enabling her to discard unnecessary pretexts to justify these nude representations. In 1923, she did two works of remarkable quality in which she staged heavy, coarse, and deliberately unattractive models. The first one, *Two Nudes*[38] is an outdoor scene, while the second, *The Bathers* (fig. 9) shows two women indoors, seated on a carpet, their pale and dark beauty contrasting. Valadon has once more abandoned the concepts of classical canons. She treats the bodies with a frankness close to brutality that negates any conventional sexual appeal. With an eye for opposites, she has chosen a redhead and a brunette for her models. The complex composition is spread diagonally in a restricted space that comprises all three grounds. Valadon's realistic approach, where each adipose protuberance is recorded on nude bodies, each fold of the draperies noted, gives the work an extraordinary immediacy. The figures' monumentality and their careful placement create a sculptural unity seldom achieved before by Valadon.

Valadon used two different draped fabrics for the background of the work. It is interesting to note that she used her favorite pattern on the

edge of the right curtain. It was called by Valadon the "drapery with the eyes"[39] because she felt that some of the forms on the print were shaped like eyes with lashes. The drapery appeared in several of her nudes, portraits, and still lifes between 1920 and 1936.

In *Two Nudes*, Courbet's *Bathers*[40] is unmistakably suggested in the pose of the model on the right, her gesture already seen in that of the standing nude turning her back in *Joy of Living*. *Two Nudes* and *The Bathers* show Valadon's absolute control over stylistic and compositional elements. Starting with the most conventional theme of women bathing used by Renaissance artists, as well as by the Impressionists, Valadon has given it a most untraditional treatment. She has succeeded in combining the stark realism of minute details with the flowing lyricism of monumental figures, thus creating a synthesis that celebrates her creative personal inspiration.

The image of a lone nude woman, standing, sitting, or reclining is one frequently encountered throughout Valadon's œuvre. Between 1916 and 1930, the artist focused intensely on this subject. *Black Venus*, (fig. 10) was exhibited at the 1919 Salon d'Automne, and it is an interesting illustration of Valadon's artistic evolution. Although other artists' influences can be traced in this work, they are only used as points of reference within the frame of the artist's personal style.

In 1919, Valadon did a series of paintings posed for by a mulatto woman who was Maurice Utrillo's mistress at the time. Valadon's interest in this model was stimulated by the challenge of a dark complexion, which offered her the opportunity to use a different palette. The work's initial source is intriguing within Valadon's cultural context. It was undoubtedly inspired by the classical Hellenic *Knidian Aphrodite* (fig. 11)

sculpted by Praxiteles around 350 B.C. This statue is one of the most copied art works, and Kenneth Clark counts forty-nine full-size replicas in the world,[41] a few housed in Paris. Valadon has adopted the goddess's pose for her version. The *Black Venus* stands elegantly, her weight shifted to her right leg, the left bent as if she were about to take a step. This movement, beginning at the waist, creates a swing of the hip, a motion called, in French, "déhanchement."[42] The woman's right arm is slightly bent and crosses her body, hiding the pubic area. It is the familiar pose of *Venus Pudica* or the *Venus of Modesty*.[43] Praxiteles' *Aphrodite* holds the shift that she has removed from her shoulders as she prepares to step into the ritual bath. The hand of the *Black Venus* rests on a thick draped cloth that could be a large towel. She stands amid green-leafed trees, as did the *Knidian Aphrodite* in her sanctuary on Knidos, in the Turkish mainland. The goddess was surrounded there by luxuriant fruit trees and vines that set off her "white radiant figure."[44] However, the coloring of the *Black Venus* does not evoke Praxiteles' goddess but the pageantry of Gauguin's Polynesians. Valadon is still attracted to the exiled artist's colorful figures, his exuberantly filled backgrounds, and his shallow space. But hers is only a superficial interest in exoticism, far from Gauguin's preoccupation with mystical symbolism.

In this painting, Valadon has disregarded her predilection for solid and thick-bodied women. Her Venus is tall and pliant, her height and erect posture emphasizing the length of her limbs. Although endowed with heavy breasts never seen on a Greek statue, Valadon's Venus, unlike her other nudes, displays the long firm legs and flat stomach of a dancer. She wears makeup, and a red bandanna hides her forehead. There was, at the time of this painting, a strong

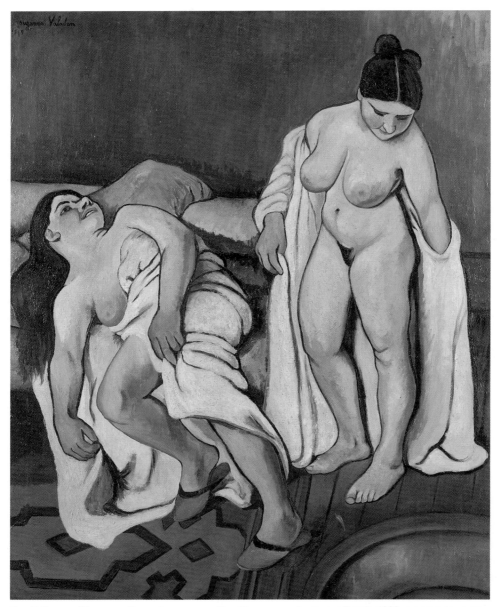

FIG. 8 NEITHER WHITE NOR BLACK *(ALSO CALLED* TWO FIGURES *AND* AFTER THE BATH*), 1909, OIL ON CARDBOARD, 40 ½ X 32 ¾", MUSÉE NATIONAL D'ART MODERNE, CNAC GEORGES POMPIDOU, PARIS, P 14*

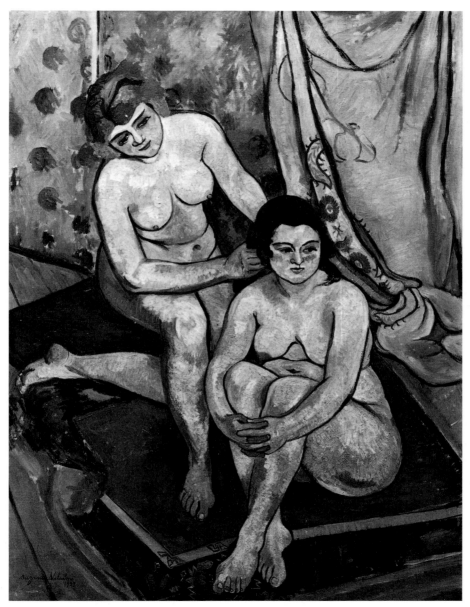

FIG. 9 THE BATHERS, *1923, OIL ON CANVAS, 46 X 35", MUSÉE DE NANTES, FRANCE, P 271*

interest in French art in the desirability of women of color.

Maurice Utrillo has described in a sonnet the palette used by his mother in this composition. He mentions "her magic colors, her natural and honest tones, her use of flat pinks to paint Whites (people) and sepia for Negroes. . . or rather for Negresses. . . ."[45] Indeed, Valadon's colors are magical: autumnal arrays of rosy to dark browns that surround, like precious jewel settings, the golden tones of Venus's flesh. Spots of green are scattered through the ground and the rocks. Valadon has relieved the possibly dull impact of tawny overall coloring by inserting the striking white accent of the draped towel. The woman's form is outlined with black, whereas the folds of the white cloth are indicated with blue, as Valadon turns to colored edges to delineate her forms.

Valadon used the black model for several paintings that include *Sleeping Black Woman* (also called *Reclining Slave*), where the girl turns her back to the viewer (perhaps inspired by Gauguin's 1892 *Manao Tupapau*). She also painted *Mulatto Eating an Apple*, where the model is seated. *The Sleeping Woman* series points to the influence of Matisse's *Blue Nude*.[46] The latter's excessive simplification, large areas of saturated color, and stylization of forms were probably seen by Valadon at the Salon d'Automne shows where Matisse had exhibited since 1903. Regardless of Valadon's references to artists as disparate as Praxiteles, Gauguin, and Matisse, there is no incongruity in her *Black Venus*. She looked at many sources and used them selectively in the context of her own inspiration and style. The result is unique, harmonious, and above all, beautiful.

The motif of the Odalisque[47] recurs frequently throughout Valadon's œuvre, but its treatment in *Reclining Nude* (fig. 12) is most unusual compared to that of her other nudes. In the other works, the nudes are presented in an attitude of trust, and their nudity, devoid of any sexual undertones, proclaims their physical and mental relaxation. Shown alone, or paired with other females, the models seem unconcerned with the possible intruding gaze of some voyeur (*Joy of Living*). Such is not the case with the sitter of the inaccurately translated *Reclining Nude*. The French title reads, "Nu," a word indifferently applied to any person without clothing. In this composition, Valadon's model is not "nude," but naked,[48] and she seems painfully aware of this condition as she lies on a sofa, exposed, unprotected, and vulnerable. She folds a defensive arm across her breasts, and her right hand clutches nervously the edge of a white cloth. Her legs are tightly crossed and pulled up toward her, in an attempt to hide her pubic area. A tense curling of her toes reveals her embarrassment. While the gesture of the *Black Venus*, covering her groin with her hand, can only be read as the duplication of a classical pose, the recoil of the *Reclining Nude* expresses her shocked reaction to an unwelcome intrusion. The woman's face registers disbelief, or perhaps fear. As with most of Valadon's sitters, she displays a strong and healthy body.

Valadon has freed the composition of any straight lines, using only curved ones. Arabesque, rounded shapes and volumes fill the surface of the painting. These curvatures, traditional signifiers of "femininity," so unexpected of Valadon, are negated by the vigor of the style as well as by the robust compactness of the woman's figure. The whole composition revolves around the model's body. Its pearly flesh is enhanced by the surrounding light green that casts a soft glow on the figure and the pale face. Valadon has skillful-

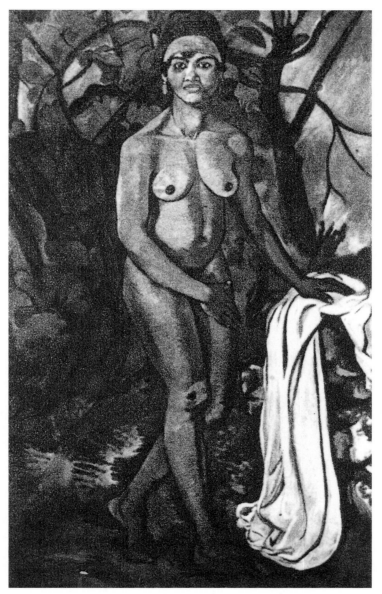

FIG. 10 BLACK VENUS, *1919, OIL ON CANVAS, 62⅞ X 38¼", MUSÉE DE MENTON, FRANCE, P 229*

Fig. 11 The Knidian Aphrodite, *attributed to* Praxiteles, *c. 350 B. C.*

curled in a fetal position and imprisoned by the arch of the sofa frame. The visual harmony of light greens and pinks is disrupted by the intrusion of a shockingly white material held by the woman and covering part of the upholstery. In many of her compositions, Valadon introduced similar white draped fabric as a neutral element to set off the value of the surrounding hues. In *Reclining Nude*, as in all of her works, the artist has edged the contours of each form with dark outlines, choosing in this particular composition midnight blue, a color less severe than her previous black ones.

The female nude continued to be a theme in Valadon's œuvre. But the morphology of her models underwent a progressive transformation. The stocky, often homely faces and bodies of the common and unattractive women whom she used as her first sitters lost some of their coarseness, and their ankles and wrists were trimmed down. If the figures retained their peasant solidity, it seemed backed by muscles rather than layers of fat. They shed, too, some of their years. *Reclining Nude* seems pounds lighter and a decade younger than the *The Brunette and the Blonde*. As Valadon lost her youth and her physical beauty, she felt a fascination, free of envy, for young women whom she continued to paint until her death. Actually, her last known works are two similar paintings, both called *Nude Standing near a Fig Tree.*[49] The model's long legs give her figure a robust elegance. Her face is lovely with the purity seen in the very young. In her old age, it seems that the quality most valued by the artist was youth. In 1936, she did a simple still life. A few flowers are assembled in an earthenware vase that displays the inscription: *Vive la Jeunesse,*[50] or "Hurrah for Youth."

ly used the busy floral pattern of the upholstery and the uneven creases of the cushions to reinforce the sculptural impact of the lying nude that stretches monumentally from one side of the canvas to the other. The woman is

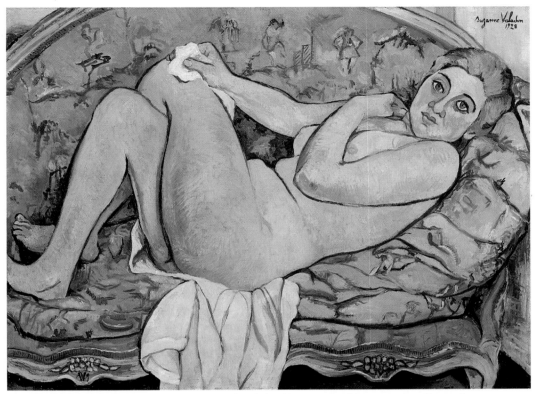

FIG. 12 RECLINING NUDE, *1928,* OIL ON CANVAS, *23 ¾ x 31½",* METROPOLITAN MUSEUM OF ART, ROBERT LEHMAN COLLECTION, NEW YORK, *P 364*

1. For instance, all nude female bodies were shown hairless.

2. Paula Modersohn-Becker, *Bust Portrait with a Necklace,*1906, *Portrait with a Loincloth,* 1906, and a full-figure *Nude Portrait,* 1906. Valadon did her first nude self-portrait as Eve in *Adam and Eve* in 1909 (fig. 4).

3. She became a full member of the Salon d'Automne in 1920.

4. Doris Kroninger, *Modell-Malerin-Akt*, Darmstadt, Germany, 1986, p. 48.

5. Carlo Cesare Malvasia, *Felsina Pettrice, Vite de Pittori Bolognesi*, Bologna, 1678 Edition, Bologna, 1841, 177 ff.

6. See *Women Artists, 1550–1950*, Anne Sutherland Harris and Linda Nochlin, exhibition catalogue, Los Angeles County Museum of Art, N.Y., 1977, p. 111.

7. As reported in *Women Artists*, p. 165; also see Whitney Chadwick, *Women, Art, and Society*, London, 1990, p. 20.

8. *Women Artists*, p.170; also Denis Diderot, *Diderot Salons*, 1759–79, III, ed. Jean Adhemar and Jean Seznec, Oxford, 1957–67, p. 125.

9. Dahlem Museum, Berlin, No. 3/55.

10. *Women Artists*, p. 176

11. Kenneth Clark, *The Nude*, Princeton, 1990, p. 3.

12. As quoted by Warnod, p. 65.

13. Puvis de Chavannes, *Sacred Wood*, 1884, Musée des Beaux Arts de Lyon, France.

14. Adolphe Tabarant, "Mémoires d'un modèle", *Bulletin de la vie artistique*, 12/15/1921, pp. 627–628.

15. André Utter, *Valadon à sa Toilette*, 1913, Petit Palais, Genève; *Valadon Nue*, 1915.

16. c.f. Pétridès, P 22. See Pétridès' description, p. 284.

17. D 137 and D 138

18. *Games*, 1910, oil, private collection, France, P 24; *Pastoral Scene*, 1910, oil on cardboard, 21⅝ x 18⅛", private collection, Paris, P 25.

19. A study for the sitting male exists: *Nude Man Extending His Left Arm*, pen and ink over tracing paper, 61 x 48⅛", D 145. Its date should be 1909, rather than 1908.

20. Renoir, *Bathers*, 1887, Philadelphia Museum of Art.

21. Barbara Ehrlich White, *Renoir, His Life, Art and Letters*, N.Y., 1984, p. 168.

22. This mythological theme is suggested in *Suzanne Valadon*, 1967, p. 402.

23. A term applied to scenes painted out of doors with the intention of capturing this quality.

24. Matisse, *Bonheur de Vivre*, 1905–06, Barnes Foundation, Merion, PA.

25. She is in the same pose, and wears a drapery similar to that of the woman in the background of Manet's *Dejeuner sur l'herbe*, 1863, Musée d'Orsay, Paris.

26. Courbet, *Bathers*, 1853, Musée Fabre, Montpellier, France.

27. P 47, P 48, P 49, P 50, P 51.

28. D 184 (1913).

29. D 187, D 188, D 189, D 190 (1913).

30. Frederic Bazille, *Fisherman with a Casting Net*, 1868, private collection.

31. Nos. 1159–1161. Valadon started to show at the Salon d'Automne in 1909.

32. *Suzanne Valadon*, 1967, pp. 40–41.

33. Interview with Geneviève Barrez, February 6, 1993.

34. See Yves Bonnat, *Valadon*, Paris, 1967, p. 40.

35. Pont Aven is a small town in Brittany where Gauguin lived between 1886 and 1890, and where he met Emile Bernard. It gave its name to an art movement characterized by a mixture of local folklore, esoteric concepts, and strong Catholicism.

36. Quoted in *Suzanne Valadon*, 1967, p. 8.

37. See footnote 52, Chapter II.

38. *Two Nudes*, 1923, oil on canvas, 64 x 51¼", private collection, P 270.

39. Interview with Geneviève Barrez, September 3, 1992.

40. See footnote 26.

41. Kenneth Clark, p. 83.

42. Ibid., pp. 80–81.

43. Ibid., p. 86.

44. Ibid., p. 86.

45. As quoted in *Suzanne Valadon*,1967, p. 46.

46. Matisse, *Blue Nude*, 1907, Baltimore Museum of Art, Cone Collection.

47. Already seen in *Blue Room*.

48. See Kenneth Clark, p. 3.

49. P 475, P 476 (1938).

50. P 466 (1936).

CHAPTER IV

LANDSCAPES AND STILL LIFES

Nature has a total hold on me. I am passionately and profoundly charmed with the trees, the sky, the water.

—SUZANNE VALADON, *ATTESTATION*[1]

I t was only around 1910, upon Utter's urging, that Valadon found the courage to paint the nature she loved so well. Her first known landscape is *Tree at Montmagny Quarry*,[2] a work started in the small village where Valadon lived until 1909 with her husband, Paul Mousis, her son, and her elderly mother. It is there that she first met André Utter, who had become a friend of Maurice Utrillo. Utter was "convalescing" from an excess of hashish and

ether in which he was indulging in Modigliani's company. Utter was overwhelmed by Valadon's personality and beauty. He never forgot how she first appeared to him: "a still young woman, full of life, holding two German shepherds on a leash."[3]

When she married Paul Mousis on August 5, 1896, Valadon moved to Pierrefitte, a small village in the Val de l'Oise, fifteen miles outside of Paris. Her husband later decided to build their own home at the nearby Montmagny. He kept the studio at 12 rue Cortot in Paris, where the artist could work peacefully. Valadon often drove herself to Paris in a light carriage drawn by a mule and escorted by five jumping Alsatian dogs.[4]

Dated 1910, *Tree at Montmagny Quarry*, must have been completed in Montmartre in the studio of the Impasse Guelma, where Valadon moved with Utter after she left Mousis.[5] The landscape's strong areas of color suggest Gauguin's influence, but the extreme linearity, the conventional centering of the heavy tree, and expressive network of curving lines already indicate Valadon's mature style.

The artist did not pay much attention to landscape as an autonomous genre until 1913, when she went to Corsica with Utter and her son. It was there that she did the sketches for *Casting of the Net*. The several drawings and paintings of the local countryside have an interest that extends beyond their initial background function. With great patience, Valadon observed the local countryside with its hills and rugged slopes and occasional nestling villages and small towns. She painted the small paths that ascend the low mountainsides, the uneven stone walls separating the fields, the arid vegetation, and the olive trees that shade the low, squat houses. She described what she saw: "There is the Mediterranean Sea and there is the mountain,

there [are] the bush and the torrent, the chaotic rocks and the sun . . . a sun unlike any other . . . bursting, caressing, decorating and embellishing [everything]."[6]

"A jumble of houses, walls, gardens, a true objective view of a town exactly as I saw it during this summer"[7] is what she painted in *View of Corté, Corsica* (fig. 1), the extraordinary recreation on canvas of an entire city. Valadon painted a view of another Corsican city, *Belgodère*,[8] but the representation was limited to a small area centering around the local church. Valadon's breadth of vision in *View of Corté, Corsica* is unusual for the artist. It encompasses a large panorama that stretches up to the top of the gentle twin mountains rising in the background. In most of her landscapes, the artist avoided developing large vistas, a trait perhaps learned from her son, whose paintings mostly dealt with views of single Montmartre streets or partial sights of towns or villages.

Valadon has chosen a high vantage point to give us almost an aerial view of Corté. She has recorded with painstaking attention each detail of the small city and its surrounding landscape. Every stone of the low foreground wall has been drawn, every window of every house reproduced, every bush, every yew tree accounted for. However, in spite of her intense detailing, Valadon does not succumb to Mannerism since, while presenting each individual part of the composition, she has kept her mind on its entirety. One is reminded of some of Dürer's Italian landscapes where the German painter's unusual interest in topography led him to draw what Kenneth Clark called "the first portraits of a town."[9] Indeed, it is the portrait of Corté that Valadon offers us, and it is the same curiosity and earnest desire to present every tangible detail that motivated Valadon as it did Dürer.[10]

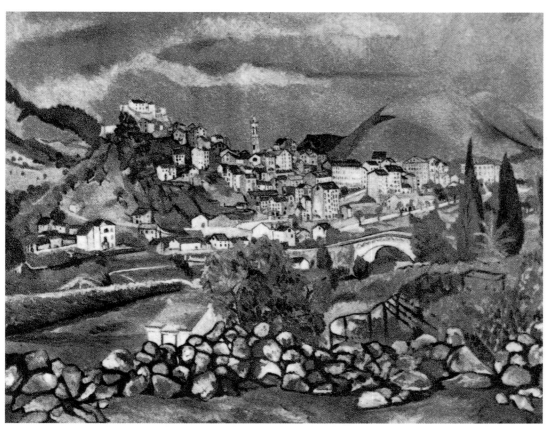

FIG. 1 VIEW OF CORTÉ, CORSICA, *1913, OIL ON CANVAS, 28⅜ X 35⅞", PRIVATE COLLECTION, PARIS, P 52*

Corsica presented a choice setting for Valadon's graphic art. In the blinding sun and bright light, the land, trees, mountains, and rocks stand out with a crisp sharpness that must have gratified the artist's unwavering sense of linearity. Valadon, raised under the cloudy skies of Paris, had never been to any Mediterranean shore before she traveled to Corsica. She had gone to Brittany in 1912, but its grandiose beauty did not disorient her in the way that her first contact with Corsica must have done.

Certain elements of *View of Corté, Corsica* speak of Cézanne. Valadon's plunging vantage point, the solidity of her structures, and the static quality of a reconstructed nature evoke the series of *Mont Sainte Victoire*.[11] But she did not use Cézanne's passage, and she has enclosed each shape with exacting dark contours. While Cézanne invested the Provence mountain with the holiness of an ancient site,[12] no such reverence is apparent in Valadon's view of Corté, where her main concern is a faithful rendering of the site.

What further links Valadon to the Master of Aix is her emotion. If her wonder in the presence of nature lacks the mysticism of Cézanne's approach, she shares his deep feeling of awe as she faces the scene. Corsica's rugged mountain etching its sharp outlines on the bright sky, the Fauvist colors of scorched vegetation, and the occasional oasis of greenery under the shading trees enchanted Valadon. It is this rapture with a new side of nature that is evident in *View of Corté, Corsica*. The artist's minute description of every detail of the site finds its source in what she herself described as a need "to render with fondness and devotion, the nature she loved so much."[13]

Valadon's attachment to nature was not limited to landscape. Her "nature" encompassed more than the trees, the sky, and the water. It included cities, streets, houses. She fervently and enthusiastically recreated on canvas some of the places she loved best. Her favorite cityscape was the rue Cortot, a small street near the Place du Tertre, where she spent an important part of her adult life.

She had occupied a small apartment at No. 2 on this street before her marriage. During her brief affair with Eric Satie, she had visited the musician's minuscule room at No. 6. After Paul Mousis had moved her and her family to Montmagny, he rented a studio at No. 12 for her, where she could work peacefully. When she left her husband, Valadon returned to Montmartre, briefly taking a studio at 5 Impasse de Guelma, but she returned toward the end of 1909 to 12 rue Cortot. There, she took over an atelier recently vacated by Emile Bernard, whose warning she left nailed to the door: "No one should enter here who does not believe in God, Raphael and Titian."[14] She lived and worked there for twelve years, between 1914 and 1926. She did twelve paintings representing the garden of the rue Cortot, as well as three views of the nearby Sacré Coeur.

On the grounds of No. 12 rue Cortot stands an ancient house that has become the Musée de Montmartre. Built during the reign of Henri IV, it became known as the "Maison de Molière" when purchased in 1680 by Roze de Rosimond, a comedian in Molière's company. Later, the building was divided into several studios that opened into an untamed garden where lilacs bloomed all summer long. It was here, in 1875, that Renoir rented the small atelier where he put the finishing touches on the *Moulin de la Galette*, the popular near-by dance hall. Numerous other artists followed the Impressionist in the Maison de Molière, among them the cartoonist Francisque Poulbot, the Greek

engraver Démétrius Galanis, Raoul Dufy, Othon Friesz, and Maximilien Luce.

Valadon did her first *Garden of the Rue Cortot* c. 1915. The last one was painted in 1922 (fig. 2). It represents the artist's final artistic look at a site she was to abandon four years later. In 1926, leaving behind a discontented Utter, the artist moved with her son to a house in avenue Junot that had been purchased for Utrillo by the owners of the Galerie Bernheim Jeune.

The 1922 *Garden of the Rue Cortot* is graced with the buoyant quality of life that was one of Valadon's greatest gifts. The work was painted from a low vantage point at the far edge of the garden that starts at the foot of a hill. Its lush vegetation entirely covers the sharp incline that leads to the house. Although the building occupies a modest part of the canvas, its presence dominates the composition. It stands at the upper left, its bright façade partially obscured by the fan-shaped branches of tall trees. The untamed summer vegetation overtakes the largest part of the painting, and its dynamic thrust infuses the composition with a sense of bursting life. In none of her other depictions of the garden has Valadon alloted such importance to the surrounding nature. She painted different versions of the site during colder seasons. By eliminating much of the thickness of the bushes and branches, she could offer a wider view of the house. In the 1922 work, only the brightness of the salmon-colored façade and the deep red of the roof save the half hidden Maison de Molière from the invisibility that a tamer coat of paint would have induced. Valadon has effectively heightened the vivid tones of the houses by setting them against the discreetly dappled blues of the sky.

As in contrast with the exuberance of the aggressive vegetation, the house conveys a feel-ing of remoteness. It stands as a retreat at the top of the hill, almost as inaccessible as a fortress. One is reminded of Cézanne's *House with Cracked Walls*[15] that crowns the crest of a stony slope. Valadon's house rises above similarly tilted ground, devoid of perspective and dominated by the verticality of all surrounding shapes.[16]

But Valadon has only borrowed from Cézanne the difficult access to his *House with Cracked Walls*. For his arid landscape and his evocation of solitude, she has substituted an exuberant nature and the sight of a man enjoying it. This was the first time Valadon introduced a human being into the garden of the rue Cortot. Among the trees, in the center of the composition, she has placed a green gazebo. A man sits there, reading in the comfort of its shade. He becomes the focus of the picture as the viewer's eyes are attracted to the brightness of his red-striped chair. The painting might be Valadon's treatment of a classical landscape where she has replaced a conventional strolling shepherd with a prosaic twentieth-century person, peacefully enjoying his newspaper.

In view of her brewing problems with Utter, this scene of domestic bliss might be hinting at the artist's fickle and sometimes wayward husband.

From the highest point of the gardens of the rue Cortot, Valadon could enjoy a sweeping panorama that extended over the Plaine Saint Denis to embrace the Basilica of the Sacré Coeur. The church is situated at the top of the Butte Montmartre; its construction was begun in 1876 and completed in 1910. Valadon saw it slowly rising from the scaffolds, its central dome emerging like a gigantic wedding cake over the Parisian sky.

This extravagant Neo-Byzantine monument inspired many of Maurice Utrillo's paintings,

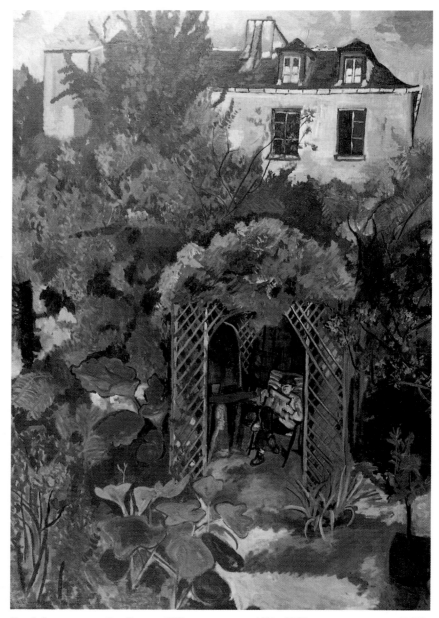

Fig. 2 Garden of the Rue Cortot, *1922, oil on canvas, 46⅛ x 37⅜", private collection, P 258*

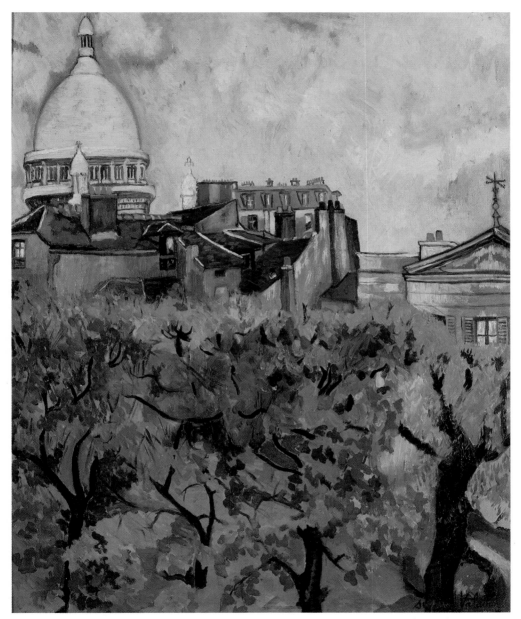

Fig. 3 Sacré Coeur Seen from the Garden of the Rue Cortot, *1916, oil on canvas, 24¾ x 20⅞",*
Musée National d'Art Moderne, CNAC Georges Pompidou, Paris, P 85

but only three of Valadon's. The first, done in 1916, was *Sacré Coeur Seen from the Garden of the Rue Cortot* (fig. 3). The basilica occupies a small part of the large vista but its main cupola is the tallest structure in the picture. In order to see it fully, the viewer's eye must travel over the wooded area of the rue Cortot garden and the maze of roofs that encircles the church. Its white dome prevails over the cloudy Parisian sky, and the tip of the gable seems to rise farther than the top of the canvas. The lower two-thirds of the composition are filled with the dense foliage of the garden, as if the artist had chosen to emphasize the country flavor of Montmartre. The solidity of the edifice that stands at the extreme right of the picture is balanced by the presence of two large areas of construction. An intricate mass of old houses is solidly anchored in the center of the composition, paralleled, at its right, by an elegant façade stretching up its elaborate weather vane.

Valadon painted a second *Sacré Coeur* the following year,[17] where she eliminated the branches that occupied the foreground. They have been replaced by large patches of uncultivated ground and a few frail trees. The group of low houses around the church has been moved closer to the viewer, who now has a full view of their façades. They nestle close to the basilica and seem to seek the church's protection, as did the villages during Medieval times.

The third and last *Sacré Coeur of Montmartre*[18] shows an overwhelming invasion of the Parisian horizon by diverse buildings. Valadon now presents a full view of two of the smaller domes of the *Sacré Coeur*, and a glimpse of the third. These were seen in the previous paintings, but their importance was played down. The foreground vegetation has now lost its luster and turns into arid and parched bushes. The progressive loss of greenery and the overcrowded sky appears to contain Valadon's message about the urban environment. It can be equated with the disappearance of a Montmartre that the artist first knew as a village; she undoubtedly mourns its countrified flavor vanquished by conquering urbanization.

When Valadon and Utter bought the castle of Saint Bernard, they were already experiencing marital difficulties. Both hoped that living together in an authentic thirteenth-century stronghold would provide the element of picturesque charm that might rekindle the passion they once shared. At first, the couple spent much time entertaining their Parisian friends and painting Saint Bernard, its surroundings, and the nearby village. But, as time passed, their relationship worsened. Valadon went there less frequently and, in 1932, her visits to the castle ceased altogether. During the previous nine years, she had done fourteen paintings of the site, and these count among her best landscapes. Furthermore, they throw some light on the artist's emotional state, as each work conveys a progressively gloomier message.

From her first bright *Landscape at Saint Bernard*[19] to the final desolate painting of the same name,[20] Valadon's moods and her vision underwent dramatic changes. It is through the different seasons that the artist expressed her mounting despair. Her first views were done in springtime, with the new leaves bursting through. Summer brought a bright sky and blooming flowers in *Bouquet in front of a Window at Saint Bernard*.[21] Suddenly came winter, its devastation, its hopelessness, and the finality of her abandonment by Utter.

In 1929, Valadon painted the *Church of Saint Bernard* (fig. 4). Although it was a time when she was already profoundly distressed, her personal problems did not affect the quality of the work. It is remarkable for its clarity of

definition as well as the vigorous handling of decorative elements.

It is almost a tragic vision that Valadon has given of the small village seen through the bare branches of the winter trees. The dull red of the roofs does not relieve the bleakness of the squat houses huddled together around the protective church. The barrenness of the scene recalls the winter landscapes of Brueghel the Elder. As in her other views of Saint Bernard, Valadon has kept a low horizon, and the pale sky offers a dramatic setting for the nude branches of the giant tree in the foreground. Their black tentacles are the strongest visual element in a toned-down composition. Valadon has restrained her palette to the earth colors in the foreground yard. They are maintained in the pale bare trunks and beige of the façades coiffed with maroon tiles. The background recedes into the washed-down blues of the lake, the rolling hills, and the horizon.

It is the influence of Cézanne that dominates in the solidly built edifices and the skeletal trees rhythmically spaced in the foreground. Valadon has perhaps remembered the chestnut trees of *Jas de Bouffan*.[22] Like Cézanne, Valadon has observed the scene from the far right, and her large tree extends its branches beyond the edge of the canvas, as the Provencal chestnut trees do.

Valadon has skillfully constructed a horizontality carried through the lines of the roofs, the far bank of the river, and the gentle curves of the low hills. However, she has energized the composition with the vertical dark edges of the trunks and the steep walls of the houses. Gauguin's lesson has not been forgotten. The strong outlines of each form betrays Valadon's interest in cloisonism and decorative patterns.

In 1932, three years after *Church of Saint Bernard* the artist painted her last *Landscape of Saint Bernard* with a fierceness and overt violence never seen before. She has reduced the scene to its essence: a few twisted trees stretch their darkened stumps into a bleak sunless sky; in the background, the church extends its shrunken steeple. The trees stand like prison bars, denying access to the church, already obscured by a low house. There is an element of disorder, chaos, and underlying violence that overwhelms the viewer. One feels the cold of winter and the artist's despair. Gone are the clear spring skies and the warm beckoning summer days in Saint Bernard. The season that now rules is winter, the climate is desolate, and what Valadon painted is despair and rejection.

STILL LIFES

Valadon's first extant still life, *Apples and Pear*, (fig. 5) was done in 1900, when she was thirty-five. By then, she had drawn nudes for seventeen years and painted portraits for eight. What were the reasons for her long delay in attempting to represent "three little apples?"[23] The main cause is obvious. As a model she never observed the artists for whom she posed painting still lifes. Therefore, she had no firsthand observation of the subject and might have thought it an unimportant genre. The images she saw on the posters, in newspaper cartoons, and even the illustrations in teaching manuals focused on the human figure and physiognomy. Although she might have seen

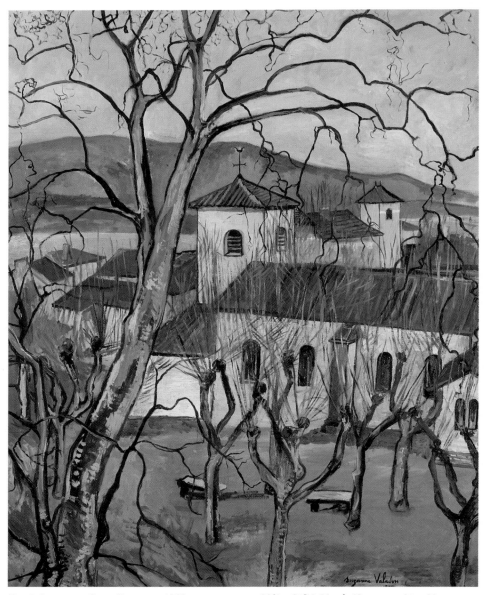

FIG. 4 CHURCH OF SAINT BERNARD, *1929, OIL ON CANVAS, 39⅜ x 31⅞", MUSÉE NATIONAL D'ART MODERNE, CNAC GEORGES POMPIDOU, PARIS, P 375*

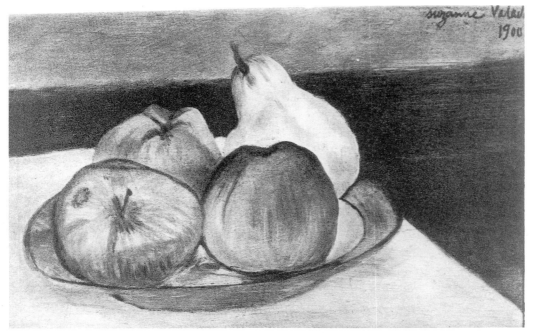

FIG. 5 APPLES AND PEAR, *1900, 7 ³/₄ x 12 ⁵/₈", OIL ON CANVAS, COLLECTION J. C. BELLIER, PARIS, P 10*

Impressionist still lifes, the artists she encountered in the streets of Montmartre were doing cityscapes. Valadon's dynamic and impatient temperament seemed ill-fitted for the contemplative nature often shown by those devoted to still-life painting. She was fascinated by people with whom she could establish an easy rapport, and though she loved nature, patience was not her main virtue. The static quality of still lifes might have been frightening for one who had never been taught the fundamental rules for their representation. But the artist gradually overcame these handicaps and has left some magnificent examples of the genre.

Apples and Pear is an unpretentious and perhaps simplistic work. Valadon assembled four pieces of fruit on a plain dish and showed them in an abbreviated setting. Since it is a first work, it bears the stigma of the artist's inexperience. However, it foreshadows, in its simplified essence, the qualities of composition and execution that are so remarkable in Valadon's mature still lifes. An extreme simplicity, caused initially by the artist's lack of sophistication, will finally prevail as her essential concern in works that epitomize her ultimate artistry.

Three apples and one pear rest on a round white dish edged with blue and placed on a table. Only a segment of its top juts into the composition in a sharp angle that brings to mind Degas' diagonal space. A white tablecloth offers a neutral ground parallel to the broad stretches of

yellowish-gray and mottled blue that divide the background evenly. These two colors, as well as the darker blue of the floor, are muted, and only the bright accents of the fruit infuse some visual life into the composition. Valadon has tried to model the apples through tonal values of yellow and red, or acid green and pale yellow, but she has used only a saturated yellow for the pear. The contours of each form have been sharply outlined with dark blue for the dish and brown and gray for the fruit.

Valadon's range of colors was, at this time, still limited. She told Tabarant that she only used five colors when she started to paint: chromium yellow, vermilion, deep madder lake, and zinc white, with the addition of ivory black and bitumen. Under Utter's influence after 1909, she devoted most of her energy to painting. She then extended her palette to fourteen colors that included yellow ocher, raw sienna, light crimson lake, Venetian red, cobalt blue, deep ultramarine, and English and emerald green. She progressively replaced black with ultramarine blue that she mixed with vermilion and English green or with reddish-brown.[24]

At first Valadon mixed her colors herself, but after a decade she resorted to the convenience of tubes. Her still lifes best illustrate her choice of colors: "It is the Impressionist palette that enchanted me," she explained, adding that she wanted this palette to remain so simple that "she did not have to think about it."[25] *Apples and Pear* testifies to this simplicity, which extends to the motif and the execution. It is obvious that Valadon planned to eliminate any problematic element. The forms that seldom overlap are reduced to circles and straight lines, the colors are primary blue and yellow with secondary green. There is no shading, and the paint is applied thinly. Valadon must have been pleased with this work for she boldly signed her name in black on the upper right corner of the background.

There is little doubt that the subject matter was inspired by Cézanne, whose work she could have seen at Père Tanguy's shop.[26] However, if apples and pears are so often seen in Cézanne's compositions, Valadon's handling of these fruits is very different from his. Cezanne's fruits exist on their own as objects to be contemplated but not consumed.[27] Valadon's apples and pear remain irrevocably lifeless, a true "nature morte,"[28] since she has not succeeded in endowing her fruits with the extraordinary presence found in Cézanne's. It is obvious that Valadon was ill at ease in handling this first still life.

Thirty-seven years after *Apples and Pear*, Valadon painted *Still Life with Fruit*,[29] a work remarkable for its subtlety of color and determined simplicity. While she has kept her interest in diagonal surfaces cutting into the canvas space, and maintains strong outlines, she now displays a great assurance of execution. With a restricted range of colors, she uses a delicate chromatism that models the volume of the fruits in a Cézannesque technique. She has placed a banana among the apples and pears, only adding a soft orange to the previous yellows and greens. The oil was painted a year before the artist's death. These were the last fruits she represented. She devoted the remaining year of her life to doing flowers.[30]

Fourteen years after it was painted *Apples and Pear* reappeared unexpectedly in the background of *Still Life with a Teapot*.[31] In this oil, the artist has assembled on a table a few apples on a white tray, a slate-gray teapot, a half-empty wine carafe, and a cylindrical vase filled with camellias and fern. In the back on the table top, a thick gold border frames a "picture within a picture" that shows the 1900 *Apples and Pear*. Three years earlier, Valadon had done an

unusual preliminary drawing for this work. It is a finished drawing that groups the elements seen in the 1914 still life. They include the *Apples and Pear* shown inside a gold frame.[32]

Although traces of awkwardness still lingered in 1914, they disappeared totally in the sumptuous *Still Life with Pink Drapery*,[33] in which the artist has assembled on a round table apples, a pedestal dish containing various fruit and a slate-gray teapot. A luxurious bouquet contains purple dahlias, dark pink gladiolas, white and blue snapdragons, and small lemon-yellow and orange carnations. This heterogeneous assemblage is happily blended under the unifying effect of a delicate pink material that gathers its folds on the table top.

This work marks the start of a series of still lifes in which Valadon disperses at random flowers, fruit, and assorted utilitarian objects, chosen for their shapes and colors. These accessories, rearranged in different combinations, are always shown with fresh flowers and fruits and often displayed near a tablecloth or a drapery.

Such is the case with *Still Life with Candle Holder* (fig. 6), in which Valadon introduces a pitcher and candle holder that will figure in several of her later still lifes. In the background, next to the bouquet, a porcelain fountain stands against the busy pattern of the wallpaper. In its basin Valadon has carelessly thrown her favorite "drapery with the eyes." The material appeared during two decades, in nudes, in a few portraits, and in many still lifes from 1920 to 1936.[34] It occupies a significant place in *Still Life with Candle Holder*, extending from the background into the foreground, where its many folds spread over half the surface. Almost magically, Valadon has succeeded in bringing together on a crowded surface a multitude of shapes, colors, and patterns. The close proximity of these elements enhances their individual essence and ultimately

contributes to the creation of a sumptuous and balanced work.

Still Life with Violin (fig. 7) epitomizes Valadon's complete mastery over the problems of an elaborate composition. After she had conquered the simplicity of her initial still lifes, she started to include within them disparate elements that added to their complexity. Functional objects, draperies, oriental carpets, one of her cats, or a dozen eggs, became essential components in many of the works she did during the 1920s. One of her most intricate paintings is *Still Life with Violin*. Although at first sight the work is deceivingly compact, upon analysis one is overwhelmed by the multiplicity, diversity, and autonomy of each detail. But, with a stylistic assurance already demonstrated in *Still Life with Candle Holder*, the artist succeeds in bringing eclectic choices of objects together into a harmonious image of richness and unity.

The violin that gives the work its title establishes the central focus of an almost square canvas. The instrument lies in its open case, resting on the rumpled folds of a deep red drapery. The open lid of the black case is lined in a strong blue, its vertical lines emphasized by the straight shape of a bow clipped inside. The violin is placed on a partly visible piece of mahogany furniture. A light molding decorates its drawer and identifies the piece as a desk. Its surface intrudes diagonally onto the picture plane, its oblique edges pointing to the viewer. A much-fingered paperback book shares the foreground. The far side of the desk supports a pale maroon pitcher filled with tulips and an ocher and greenish-blue oriental pot. On the left part of the composition, squeezed between two vases, the "drapery with the eyes" extends its meager cream-colored folds discreetly highlighted by its red and black pattern.

The architecture of the room is not clearly

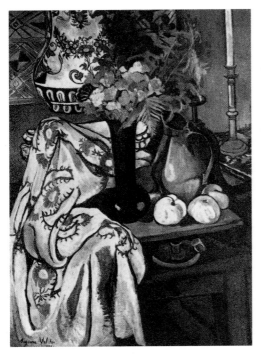

FIG. 6 STILL LIFE WITH CANDLE HOLDER, *1921*, OIL ON CANVAS, *36 ¼ X 25 ⅝",* COLLECTION PAUL PÉTRIDÈS, PARIS, P 223

of the case lining. The rich tones of sienna are echoed in the earthenware of the pitcher and the corollas of the tulips. Shining wood surfaces enhance the saturated values of the reds and blues. Valadon has introduced several touches of a complimentary dull green. It takes a yellow cast in the leaves of the flowers and turns bluish against the ocher background of the oriental vase. A darker green brings forth the golden tan of the men's limbs. Skillful touches of light tones heighten the colors' values. The yellowed white of the book wakes up the somber mahogany of the desk. Its contours edged with pale orange moldings introduce some rare straight lines amid the roundness of most of the forms.

The circumvoluted aspect of some elements and their eclecticism melt into an harmonious entity that is toned down and unified by the soothing quality of dark colors.

In spite of a style that has now become "pure Valadon," the artist has not forgotten the lessons of Degas. She has borrowed his jutting oblique shapes and their intrusion into the viewer's space. The disconcerting cropping of the fishermen's figures might have found its source in the truncated bodies of the ballerinas of the *Orchestra of the Paris Opera.*[35]

Valadon has abandoned the rigorous presentation of conventional still lifes. What she strives for is the overall beauty of form and color to which logic is irrelevant. Some of the objects chosen are seen out of their context, often sectioned off; they exist for the sole value of their harmony, for their strength, and not for their meaning. Some of the forms, particularly those seen in the background, lose their figurative significance and function as abstract shapes. The work ignores conventional restrictions. The cluttering of the details, the complexity of the composition, are unimportant.

indicated. There is a suggested angle hidden by the drapery. On the background wall, Valadon has reproduced the lower side of a fresco-like segment of part of *Casting of the Net.* On the left a fisherman's leg seems to step over the Chinese vase. A larger portion of the second man's figure appears. On his chest Valadon has inscribed her signature and the date.

To balance a bewildering array of forms and patterns, Valadon has exercised great moderation in her choice of colors. The composition is atypically dark, but it is warmed by the glowing accents of the red drapery and the intense blue

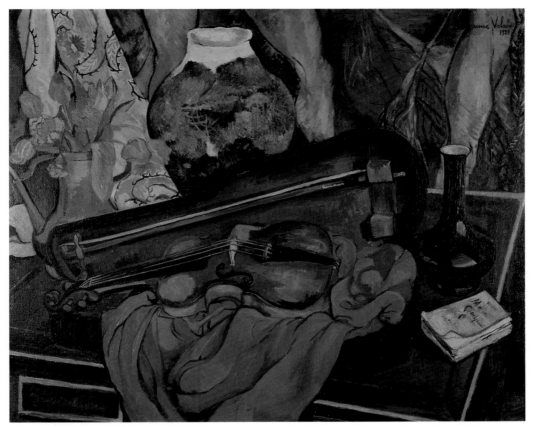

FIG. 7 STILL LIFE WITH VIOLIN, *1921, OIL ON CANVAS, 31⅞ x 39⅜″, MUSÉE D'ART MODERNE DE LA VILLE DE PARIS, P 222*

What ultimately remains is an array of forms interwoven randomly into Valadon's magical display of colors.

With a tenderness and a sensitivity so opposed to her customary clinical objectivity, Valadon has painted some admirable oils in which her deep love for flowers surfaces with lyrical accents. She called her bouquets "my friends," [36] and in no other subject matter has she attained such strength tempered by such delicacy.

Perhaps one of her most beautiful still lifes

is *Peonies and Lilacs* (fig. 8). It was done in 1929, a year mostly devoted to painting flowers. A large bouquet of peonies, lilacs, and mixed green leaves stands at the center of the composition. A simple small wooden table or stool supports an opulent faience vase out of which the flowers erupt joyously. The bouquet is asymmetrical. On its left, a bunch of peonies and some foliage are disposed in a fanlike half-circle and treated in a strong linear style. Each stem, each leaf, and each corolla has been

precisely outlined with dark blue. The orderly arrangement is offset on the right by an unruly array of loosely painted lilacs and leaves. The flowers burst freely out of the vase, randomly extending their purple clusters.

The creamy whites and pinks of the peonies are heightened by the brightness of the nearby branches. On the left, the yellowish, almost fluorescent green of the leaves deepens into dark emerald shades that enhance the delicate mauve of the lilacs.

Near the base of the vase, Valadon has tossed a paisley shawl. The creases of the fabric disrupt the regularity of the pattern. The subtlety of the material's reds and blues lend a touch of understated sophistication to the composition.

The central location of the bouquet establishes it as the focus of the work. It becomes the source of all forms, of all colors, of all energy. Its presence is enhanced by the subdued sienna of the pottery and the discreet glow of the table's wood surface. Potent accents of color originate in the stained-glass blues and reds interwoven into the shawl's fabric. Valadon has tried to soften the parallelism of the table legs, the abrupt angles of the walls, and the squareness of the window panes. The rigor of the geometrical lines is relieved by the rotundity of the vase and the asymmetry of the bouquet.

There is a marked dichotomy in the stylistic treatment of the composition. The linearity that prevails in the foreground turns progressively more painterly as the eye travels to the background. The flowers' sharp contours melt into an atmospheric blurriness and become unfocused spots of color. The back window fails to provide a source of light, and as happens in many of Valadon's works, there is no apparent light source.

The bouquet is placed in the front of a large room. This is an unusual setting for the artist who showed most of her still lifes in restricted horizontal surfaces similar to those of Cézanne. Her flowers are often presented in a shallow space delimited by a polychromatic background.

In *Peonies and Lilacs*, Valadon has created an effective sense of space through the receding effect of a large dark blue curtain that stretches on the left side of the painting, next to the sharp angle of a wooden door. The background seems to have been observed from a higher vantage point than the rest of the room. The oblique lines of the curtain do not follow the conventional laws of one-point perspective, and their sharp angles create the further illusion of deep space. The darkness of the curtain is echoed on the opposite wall in the black rectangles within the open window.

Valadon has left the back wall uncluttered, and nothing lures the viewer's eyes away from the exuberant opulence of the flowers. In depicting them, the artist shows an unusual concern for botanical verisimilitude. She has faithfully reproduced their actual shapes and colors. She brings forth the tender blush of the peonies as well as the soft tonal graduation of the lilac's purple pinnacles. Predominantly using graduated shades of blue, she has restrained her palette to a range of soft pinks that progressively ascend to a light purple. Only the sienna of the pottery and the deep reds and blues of the paisley shawl offer dominant notes of brightness. The artist used an unexpected thin paint that seems to coat the surface with a satiny finish.

Valadon did *Peonies and Lilacs* when she was sixty-four. She had reached the peak of her artistic maturity. In this magnificent oil, she succeeded in combining the rigor of a carefully constructed composition with a spontaneous eruption of forms and colors. On the left side of

the canvas, she controlled the areas of colors with strict outlines and tamed the shape of the floral arrangement. On the right, she imitated nature's spontaneous artistry and gave freedom to the burst of the lilacs. She strove to contrast the cool blues with the subtle warmth of the varied pinks.

Peonies and Lilacs marks an important step in Valadon's evolution. It testifies to her decision to free her compositions of the accessories that, at times, cluttered her pictorial space; eliminating details allowed her to give her full attention to her main subject: the depiction of flowers. They were her greater love and throughout her career she never ceased to paint them with a care and an attention she sometimes did not extend to the human race.

One of Valadon's greatest qualities was her unquenchable curiosity about whomever and whatever surrounded her. This interest surfaces in her works. Although she loved life and often depicted her cats and dogs, she also occasionally included dead animals in a few of her still lifes. Pheasants, wild ducks, partridges, and hares, all shot during the hunting season at Saint Bernard, lie on kitchen tables or are tossed on the caned seat of a chair. At times she paints the chickens and rabbits that will later grace some of the castle's meals. But Valadon did not linger over these dead animals, preferring instead to work on the flowers that symbolized life to her. During the last few years of her life, she captured them on her canvas. Shown alone, or assembled in opulent bouquets, they emerge from a plain glass or a crockery container. They stand on a tabletop or on a windowsill, occasionally juxtaposed on a landscape background. Now and then she drapes some material on a nearby object or on the wall.[37]

The objects that crowded the space of her still lifes until her last decade were there to challenge the artist's skill but never lessened the importance she gave to the flowers. When she ultimately realized that she had conquered most of her stylistic difficulties, she used the flowers by themselves, certain that their beauty alone was worthy of her full attention.

The simplification observed in Valadon's last still lifes is apparent, too, in her late portraits and nudes. When she reached her artistic maturity, the artist rejected the decorative devices and the inessential details that crowded her early works, to capture only the essence of her subjects.

Perhaps Valadon had a premonition of her impending death. In her last years she gave several small oils to the people whom she loved. The artist was not articulate when she spoke, and even less so when she wrote. She felt she could best express her feelings of affection and respect with the gift of what she valued most: her flowers. Many of these paintings were of roses, and they bore personal inscriptions, such as "To Mauricia, the beautiful and great Mme. Coquiot."[38] The painting of a single rose in a glass went to Doctor Gauthier "as a souvenir of a conversation, so unforgettable because of his right and enlightened ideas on Art."[39]

One of the recipients of these gifts of flowers was Dr. Le Masle, Valadon's friend and most avid collector. He bequeathed his important collection of her paintings, drawings, and etchings to the Musée National d'Art Moderne in Paris, one of the more than forty museums all over the world to own the artist's works. Dr. Le Masle was the first of Valadon's devotees to realize the importance of her innovative concepts as well as the greatness and strength of her œuvre. It was because of his persistent efforts that the Paris city government named a square in Montmartre, Place Suzanne Valadon.

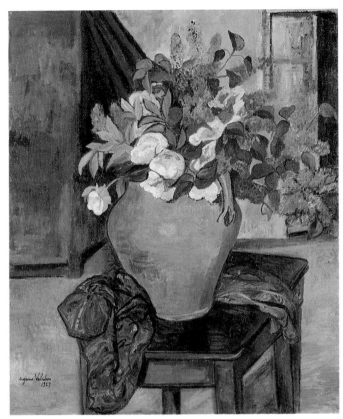

FIG. 8 PEONIES AND LILACS, *1929, OIL ON CANVAS, 39¼ X 31⅞",*
METROPOLITAN MUSEUM OF ART, NEW YORK, P 367

It was upon Le Masle's urging that a coin in Valadon's honor was issued in 1949. It was etched by the sculptor Pierre Poisson. On one face of the medal was the profile of the artist inspired by her 1883 self portrait; on the reverse, a heart with a rose. The center bears Valadon's motto: "To give, to love, to paint."

1. Suzanne Valadon, *Attestation*, Archives of the Musée National d'Art Moderne, CNAC Georges Pompidou, Paris, VAL Ma 149–157–158–159.

2. *Tree at Montmagny Quarry*, c. 1910, oil on canvas, 21¼ x 28¾". The Carnegie Museum of Art, Pittsburgh, PA; Acquired through the generosity of Mrs. Alan M. Scaife, 65.17.2. P 31.

3. As described by Utter himself in *How to Become a Painter*.

4. As described by Peter de Polnay, *Enfant Terrible: The Life and World of Maurice Utrillo*, N.Y., 1959, p. 48.

5. Number 5 Impasse de Guelma was a small building divided into five studios occupied

by artists. Braque and his wife lived there, as well as Severini and Raoul Dufy. For more details on the site, see Pierre Courthion, *Montmartre*, Skira, Cleveland, OH, 1956, p. 106.

6. See Michelle Deroyer, p. 188.

7. Ibid.

8. *Belgodère*, 1913, oil on canvas, 29 ⅛ x 36 ¼", P 47.

9. Kenneth Clark, *Landscape Into Art*, N.Y., 1979 reprint, p. 41.

10. I am grateful to Geneviève Barrez for calling my attention to Dürer's landscapes.

11. Mont Sainte Victoire is a mountain between Aix-en-Provence and Marseilles that Cézanne painted in many versions.

12. See Meyer Schapiro, *Cézanne*, N.Y., 1988, p. 84.

13. Valadon, *Attestation*.

14. For further details, see "Ateliers de génie," *Salon des Indépendants*, Paris, 1983, pp. 36–37.

15. Cézanne, *House with Cracked Walls*, 1892–94, private collection.

16. See Schapiro, p. 110.

17. *Sacré Coeur*, 1917, oil on canvas, 31 ⅛ x 24 ⅜", private collection, P 86.

18. *Sacré Coeur of Montmartre*, 1919, oil on canvas, 24 ⅞ x 20 ⅞", private collection, P 129.

19. *Landscape at Saint Bernard*, 1923, P 257.

20. *Landscape at Saint Bernard*, 1932, oil on canvas, 31 ⅞ x 25 ⅝", private collection, P 436.

21. *Bouquet in front of a Window at Saint Bernard*, 1926, P 324.

22. Cézanne, *Chestnut Trees at the Jas de Bouffan in Winter*, 1885–86, Minneapolis Institute of Arts, MN.

23. This expression often refers to Cézanne's multiple compositions of apples.

24. Interview with Geneviève Barrez, September 11, 1992.

25. *Suzanne Valadon ou l'absolu*.

26. Père Tanguy (1825–1894) opened a small store in Montmartre in 1867, where he first sold colors he ground himself. Among his customers were Pissarro, Guillaumin, Gauguin, and Cézanne. Tanguy later placed in his window some of the works of his yet undiscovered clients.

27. For an in-depth analysis of Cézanne's œuvre, see John Rewald, *Cézanne*, N.Y., 1986, and Meyer Schapiro, *Cézanne*, N.Y., 1988.

28. "Dead nature," the French expression for a still life.

29. *Still Life with Fruit*, 1937, oil on canvas, 12 ½ x 15 ⅝", Carnegie Museum of Art, Pittsburgh, PA, P 459.

30. She painted flowers with the exception of her last two works, which were nudes: P 475, P 476, both dated 1938.

31. *Still Life with a Teapot*, 1914, oil on cardboard, 20 ⅞ x 26", private collection, Paris, P 92.

32. Valadon did only two other still-life drawings: *Flowers in a Pitcher*, 1903, pastel and colored pencils, 16 ⅞ x 12 ⅝", private collection, Nice, D 98, and *Flowers in a Glass Jar*, pastel, 15 ¾ x 8 ¾", private collection, Paris, D 99.

33. *Still Life with Pink Drapery*, 1919, oil on canvas, 31 ½ x 22 ⅞", collection P. Pétridès, Paris, P 165.

34. P 175, P 198, P 218, P 224, P 241, P 242, P 297, P 467, P 473.

35. Degas, *Orchestra of the Paris Opera*, 1868–69, Musée d'Orsay, Paris. Only part of the stage is shown, with the dancers' upper bodies cut off.

36. Interview with Geneviève Barrez, June 13, 1992.

37. For instance, she used the "drapery with the eyes" in P 467 and P 473.

38. *Two Flowers in a Stem Glass*, 1932, P 447.

39. *The White Rose*, 1936, P 469. The awkwardness of Valadon's French is reflected in the English translation.

CHRONOLOGY

1865
September 23:
Birth of Marie-Clementine Valadon, daughter of Madeleine Valadon, thirty-four years old, sewing maid, and unknown father, in the town of Bessines-sur-Gartempe, Haute Vienne, France.

Christened on September 24: godfather, Matthieu Masbeix; godmother, Marie-Aline Coulaud.

1865 to 1870
Mother and child move to Paris. Madeleine works as charwoman. Marie-Clementine is sent briefly to Nantes to her half-sister Marie-Emilienne, then back to Montmartre. Attends religious school until 1876.

1873
Starts drawing.

c. 1876 to 1880
Apprentices in dress factory, florist shop, and outdoor market.

1880
Lives with mother. Works briefly in a circus until an injury from a fall prevents her from performing there. Becomes a model for Puvis de Chavannes (*Sacred Wood*, 1883–1884), Renoir (*Dance in the Country, Dance in Bougival, Dance in Town*, 1883; *The Braid*, 1885; several *Bathers*); Toulouse-Lautrec (two *Portraits*, 1887, *Gueule de Bois*, 1887-88); Jean-Jacques Henner, Gustave Wertheimer (*Kiss of the Mermaid*, 1884); Voytech Hynais (*Truth*, 1893); Hector Leroux (1891).

1883
December 26:
Birth of Maurice Valadon, father unknown; acknowledged in 1891 by the Spanish journalist Miguel Utrillo y Molins. Valadon moves with the child and her mother to 7 rue Tourlaque. Does first known drawings: *Autoportrait*, pastel, and *Portrait of the Artist's Mother*.

1883–1893
Makes numerous drawings modeled by her son, her mother, herself, and Miguel Utrillo—portraits, family scenes, and nude children. Degas' influence starts to be seen. There is no set date for Valadon's meeting with this artist, who wrote to her from 1894 to 1917, calling her, affectionately, "Terrible Maria."

1893
Has affair with Eric Satie, who lives next door. First known paintings: *Portrait of a Little Girl, Portrait of Eric Satie, Portrait of Bernard Lemaire, Tale to a Child*, and *Young Girl Crocheting*, probably started in 1892.

1894
Perhaps encouraged by Degas—who buys a drawing—and Bartholomé, sends five drawings to the Salon de la Nationale, where they are exhibited: *Toilet of the Grandson* (No. 1670), *Grandmother and Grandson* (No. 1671), and three studies of children (Nos. 1672, 1673, and 1674).

1895
Tries soft-ground etching in Degas' atelier. Continues to draw.

1896
August 5:
Marries Paul Mousis, whom she had known since

1893. He was chief clerk in Bel and Sainbénat Co., and a man of means. They live at 12 rue Cortot and in a house at Montmagny near Pierrefitte. There, Valadon paints *Grandmother and the Little Rosalie*, her first oil since her 1892–93 series.

1896–1909
Leads a comfortable life with time for her art. Makes few paintings, but many drawings and etchings, sold by Le Barc de Boutteville and Vollard, who publishes her prints in 1897.

Maurice Utrillo, raised by his grandmother, starts drinking at an early age. Studies poorly at College Rollin. Helped by his stepfather, he works for a few months as a clerk at the Credit Lyonnais bank. Valadon consults Dr. Ellinger, who suggests teaching Utrillo to paint as therapy. Utrillo paints "against his will" but continues to drink and has to leave his parents' house.

1909
Meets one of Utrillo's friends, the painter André Utter, born in 1886 and twenty-one years her junior. Leaves Mousis and asks for a divorce. Starts to live with Utter at 5 Impasse Guelma but moves to 12 rue Cortot, to a studio vacated by Emile Bernard.

Utter convinces her to concentrate on painting. Does numerous oils, among them *Nude with Mirror, After the Bath, Adam and Eve*, and *Summer*, which is exhibited at the Salon d'Automne (No. 1677).

1911
Paints *Still Life with Teapot*, as well as large compositions, including *Nude Women under the Trees*. First solo show at Clovis Sagot. *Joy of Living* and *Hairdressing* shown at the Salon d'Automne (Nos. 1605 and 1606). Six works shown at the Salon des Indépendants (Nos. 6073–6078). Utrillo is "discovered" by Francis Jourdan, and later by Octave Mirbeau.

1912
Paints *Family Portrait, Portrait of the Artist's Mother, The Future Unveiled*.

Travels with Utter and Utrillo to Brittany on the island of Ouessant. Does several landscapes.

The Future Unveiled shown at the Salon d'Automne (No. 1658); three works at the Salon des Indépendants (Nos. 3219–21). Exhibits in Munich in a group show organized by Clovis Sagot.

1913
Paints *Marie and Gilberte, Nude Having Her Hair Combed*, and several still lifes. Travels with Utter and Utrillo to Corsica. Does fine views of Corté and Belgodère in a strong linear style.

Shows at the Salon d'Automne: *Young Girl With a Mirror* (No. 2020); and the Salon des Indépendants (Nos. 3013–14, which includes *The Tub.*)

Exhibits with seven other artists at Berthe Weil in December.

1914
Makes large masterpieces: *Casting of the Net*, shown at the Indépendants (No. 3324) and *The Seamstress*. Paints still lifes and landscapes in the Oise region. In August marries Utter shortly before he joins his regiment in Belleville-sur-Saône. Utrillo is discharged from the army and goes back to his mother at rue Cortot.

1915
Paints *Portrait of Madame Coquiot*. Has solo show at Berthe Weil. Her mother dies.

1916
Makes series of beautiful nudes after the model Gaby. Paints *Arlequin* inspired by Utter's *Arlequin*. Paints flowers and landscapes of Montmartre, and of the Oise region.

1917
Paints *Rest*, modeled by Gaby, and landscapes of Montmartre. In June, joins Utter, who had been wounded and recovering in Meyzieux military hospital. Paints local landscape. Has group show with Utter and Utrillo at Berthe Weil and Bernheim Jeune.

1918
Makes *Autoportrait*, done at Decimes, Isère, and *Portrait of Madame Gebel*, as well as nudes. Utter returns from the war to rue Cortot and presses her to work more.

1919
Does extensive work, including portraits: *Utrillo at*

his *Easel* and *The Tigress*; numerous beautiful still lifes, landscapes, large series of nudes modeled by a mulatto girl (*Black Venus, Reclining Slave*). These two paintings and two additional works shown at the Salon d'Automne (Nos. 1864–1867). Has drawing exhibition at Berthe Weil. Utrillo has first major exhibition at Lepoutre.

1920

Paints many still lifes, as well as portraits (*Portrait of Victor Rey*), nudes in elaborate setting, and genre scenes (*Small Italian Girl With a Doll*). Shows several works at "Young French Painting" at Manzy Joyant Gallery. Elected member of the Salon d'Automne, she sells one painting (No. 3139) at its yearly show. Some of her works sold at auction at the Hotel Drouot, October 22 and December 16.

1921

Does portraits of Utrillo and her niece Gilberte, as well as the *Utter Family*. Paints nudes, *The Cast-Off Doll*, and still lifes.

Takes trip to Beaujolais. Paints landscapes: *Castle at Jonchet, Cowshed in Beaujolais*. Exhibits with Utter and Utrillo at Berthe Weil, one nude at the Salon des Indépendants (No. 3437).

Four major works at the Salon d'Automne: *Family Portrait* (No. 2372), *The Cast-Off Doll*, (2373), *Gilberte* (2374), and *Portrait of Utrillo* (2375). In December, solo show at John Levy includes *Casting of the Net, Adam and Eve*. Shows two portraits at the International Exhibition of Modern Art in Geneva.

Enjoys increasing fame with public and critics, and has frequent shows and excellent press reviews written by Robert Rey, André Warnod, Tabarant.

1922

Portraits: *Lily Walton, Madame Zameron, Germaine Utter, Madame Levy*, as well as nudes and Montmartre landscapes. Trip to Genet in Brittany, where she paints landscapes.

Shows two paintings at the Salon des Indépendants (Nos. 3582 and 3583). Two nudes at the Salon d'Automne (Nos. 2247 and 2248).

Has two shows: Valadon and Utrillo at Berthe Weil in April and July; and Valadon, Utter and Utrillo at the Delpayat Gallery.

Robert Rey publishes the first monograph on Valadon.

1923

Paints *The Blue Room, Autoportrait,* as well as large nudes and still lifes. Visits the painter Georges Kars' family in Ségalas in the Basses Pyrénées.

Buys a castle at Saint Bernard in the Saône Valley. Valadon, Utrillo, and Utter have their own atelier. The trio commutes between Paris and Saint Bernard. Large Valadon-Utrillo show at Bernheim Jeune Gallery.

Exhibits two paintings at the Salon des Indépendants (Nos. 4598 and 4599); one nude and *Still Life with Pineapple* at the Salon des Tuilleries (Nos. 994 and 995); and the *Blue Room* and *Still Life With Game* at the Salon d'Automne (Nos. 1955 and 1956). Participates in several group shows, and enjoys increased public recognition. Lavish life-style for the family.

1924

Does numerous portraits, nudes, and still lifes, as well as first landscapes of Saint Bernard, which she will paint until 1932. Although frequently asked to show, exhibits only at Berthe Weil and Bernheim Jeune, with whom she signs a first contract. Tabarant gives a banquet in her honor.

Exhibits *Madame Fontaine and Her Daughter* at the Salon des Indépendants (No. 66).

1925

Valadon-Utrillo-Utter show at Bernheim Jeune. Exhibits two paintings at the Salon des Indépendants (Nos. 3343 and 3344).

1926

Bernheim Jeune Gallery buys a house for Utrillo at 12 avenue Junot, to which Valadon and Utrillo move; Utter remains at rue Cortot. Outstanding works at the Indépendants' Retrospective: *Casting of the Net* (No. 2256), *Family Portrait* (No. 2257), *Gilberte* (No. 2260), and two others (Nos. 2258 and 2259).

1927

Paints nudes, still lifes, Saint Bernard landscapes.

Retrospective show at Berthe Weil in January with a foreword in free verse by Berthe Weil. Show is acclaimed. Exhibits four paintings at the Salon des Tuilleries (Nos. 2347–2350). Does outstanding series of nudes and still lifes.

1928
Has several group shows abroad, in Amsterdam and New York. Shows two paintings at the Salon d'Automne (Nos. 2480 and 2481). Has solo show at the Galerie des Archers in Lyon in January, and at Berthe Weil in April. Is now internationally known. An important article appears in a German journal, *Deutsche Kunst und Decoration*. The following year, Adolphe Basler publishes a monograph on Valadon.

1929
Paints important landscapes at Saint Bernard. Has two shows at the Galerie Bernier: a retrospective of drawings and prints including about one hundred works, with a foreword by Robert Rey (shown from January to April); also a show of recent works.

1930
Does several still lifes and Saint Bernard landscapes. Participates in the show "Living Arts," at the Pigalle Theatre.

1931
Paints *Self-Portrait with Bare Breasts, Woman Putting Shoes on a Little Girl*, as well as many still lifes and landscapes at Saint Bernard. Participates in the exhibition of the School of Paris held in Prague. Has show of recent works at the Galerie Au Portique with a foreword by Edouard Herriot. Large retrospective in Brussels at the Galerie le Centaure.

1932
Paints *Portrait of André Utter and His Dogs* and last still lifes and landscapes of Saint Bernard.

Most important retrospective at the Georges Petit Gallery with a foreword by Edouard Herriot in the catalogue. Show well received by the press, but almost no sales. Has exhibition of drawings and prints at Au Portique and participates in group show with Utter and Utrillo at the Moos Gallery in Geneva, which includes around one hundred paintings. Daragnès publishes a luxurious book that includes the complete engraved works of Valadon; it sells poorly.

1933
Paints less and suffers drastic mood swings. Utrillo's fame increases. He becomes a devout Roman Catholic and is baptized. Valadon joins a woman's organization, Femmes Artistes Modernes (F.A.M.), headed by the painter Marie-Anne Camax-Zoegger. Shows yearly with F.A.M. until her death.

1934
Portrait of Paul Pétridès. Sees Utter only occasionally. Befriends a young painter named Gazi, who addresses her as "Mémère" and tries to have her share his profound devotion.

1935
Treated at the American Hospital in Neuilly (a Paris suburb) for diabetes and uremia. Allegedly asks Lucie Valore—the widow of Robert Pawels, a Belgian banker and collector of Utrillo's works—to marry Utrillo. However, Utrillo's departure for his mother's home is emotionally violent.

1936
Does paintings of flowers, which she dedicates to her friends, and a few still lifes.

1937
Paints *Portrait of Madame Maurice Utrillo* and *Portrait of Madame Pétridès*. The state buys *Adam and Eve, Casting of the Net*, and *Grandmother and Grandson*, as well as several drawings, for the Musée du Luxembourg, at the time a museum of modern art. The Luxembourg already owns two of the artist's paintings.

1938
Dies suddenly of a stroke at the Piccini Hospital, on April 7, at 11 a.m. A funeral service is held at the church of Saint Pierre of Montmartre.

From the catalogue written by Pierre Georgel for the 1967 exhibition held at the Musée National d'Art Moderne, CNAC Georges Pompidou in Paris.

BIBLIOGRAPHY

Art Digest. Vol. 12. Suzanne Valadon obituary, April 15, 1938, p 15.

Barotte, René. "Suzanne Valadon" in *L'art et les artistes*. Paris, 1937.

Barrez, Geneviève. *Suzanne Valadon*. Doctoral Dissertation, unpublished, Ecole du Louvre, Paris, 1947.

Basler, Adolphe. *Suzanne Valadon*. Paris, 1929.

Beachboard, Robert. *La Trinité maudite: Utter, Valadon, Utrillo*. Paris, 1952.

Beaux-Arts. Special issue on Suzanne Valadon. April 15, 1938.

Besson, Georges. "Hommage à Suzanne Valadon" in *Lettres françaises*, June 3, 1948.

Betterton, Rosemary. "How Do Women Look? The Female Nude in the Work of Suzanne Valadon." In *Visibly Female*. New York, 1988.

Bonnat, Yves. *Valadon*. Paris, 1968.

Bouret, Jean. *Suzanne Valadon*. Paris, 1947.

Carco, Francis. *La Legende et la vie d'Utrillo*. Paris, 1928.

Cassou, Jean. (Preface) *Hommage à Suzanne Valadon*. Paris, 1948.

Chadwick, Whitney. *Women, Art and Society*. New York and London, 1990.

Colombier, Pierre du. "Suzanne Valadon." In *Amour de l'art*, No. 9, September 1926.

___. "La Gloire de Suzanne Valadon." In *Beaux-Arts*. February 23, 1942.

Coquiot, Gustave. *Cubistes, Futurists, Passeistes*. Paris, 1921.

___. *Des Peintres maudits*. Paris, 1924.

Coughlan, Robert. *Wine of Genius*. New York, 1951.

Crespelle, Jean-Paul. *Montmartre vivant*. Paris, 1964.

___. *Utrillo*. Paris, 1970.

___. *La Vie quotidienne à Montmartre*. Paris, 1978.

Deroyer, Michelle. *Quelques souvenirs autour de Suzanne Valadon*. Paris, 1947.

Dorival, Bernard. *Les Etapes de la Peinture Française Contemporaine. De l'Impressionnisme au Fauvisme*. Paris, 1943.

Fabris, Jean. *Utrillo: sa vie, son œuvre*. Paris, 1982.

Fels, Robert. "Suzanne Valadon." In *L'Information*. Paris, 1931

Guenne, Jacques. "Suzanne Valadon." In *Art Vivant*. Paris, 1932.

Guilleminault, Gilbert. *Les maudits de Cézanne à Utrillo*. Paris, 1959. Essay by Anne Manson, "Suzanne Valadon la frénétique," is included on pp. 249–311.

Harris, Ann Sutherland and Nochlin, Linda. *Women Artists: 1550–1950*, see pp. 259–61, 354. Exh. cat., Los Angeles County Museum of Art, 1976.

Heller, Nancy. *Women Artists: An Illustrated History*. New York, 1987.

Herriot, Edouard. Preface to catalogue of Suzanne Valadon Exhibition. Au Portique, Paris, 1931.

___. Preface to catalogue of Suzanne Valadon Exhibition. Georges Petit Galerie, Paris, 1932.

Jacometti, Nesto. *Suzanne Valadon*. Geneva, 1947.

Krininger, Doris. *Modell-Malerin-Akt. Über Suzanne Valadon und Paula Modersohn-Becker*. Darmstadt, Germany, 1986.

Lipton, Eunice. "Representing Sexuality in Women Artists: Biography: The Case of Suzanne Valadon and Victorine Meurent." In *The Journal of Sex Research*, Vol. 27, No. 1, February 1990.

Leudet, Suzay. "Suzanne Valadon chez les Pompiers." In *Beaux-Arts*. Paris, March 6, 1938.

Mathews, Patricia. "Returning the gaze: Diverse representations of the nude in the art of Suzanne Valadon." In *Art Bulletin*. September 1991.

Matthey, Pierre. *Six femmes peintres*. Paris, 1951.

Mermillon, Marius. *Suzanne Valadon*. Paris, 1950.

Pétridès, Paul. *L'œuvre de Suzanne Valadon*. Paris, 1971.

Polnay, Peter de. *Enfant Terrible: The Life and World of Maurice Utrillo*. New York, 1969.

Prou, Suzanne. *Suzanne Valadon*. Exh. cat., Franska Instituted, Stockholm, 1978.

Raynal, Maurice. *Modern French Painters*. New York, 1928.

Rey, Robert. *Suzanne Valadon*. Paris, 1922.

Roger-Marx, Claude. *Les Dessins de Suzanne Valadon*. Eighteen original prints by Suzanne Valadon, executed between 1895 and 1910, with a preface and a catalogue. Daragnès, Paris, 1932.

Salmon, André. *L'air de la Butte*. Paris, 1945.

Storm, John. *The Valadon Drama*. New York, 1959.

Tabarant, André. "Suzanne Valadon et ses souvenirs de modèle." In *Le Bulletin de la vie artistique*. December 15, 1921, pp. 626–629.

Time. "Maria of Montmartre," Vol. 67, May 18, 1958.

Tufts, Eleneor. *Our Hidden Heritage: Five Centuries of Women Artists*, see pp. 169–177. London, 1974.

Utter, André. "Maurice Utrillo and Suzanne Valadon." In *Royal Society of Arts Journal*. Vol. 36, Oct. 7, 1938, pp. 1125–1127. Translated by G. Rees.

Valadon, Suzanne, and Bazin, Germain. "Suzanne Valadon par elle-même." In *Promethée*. March 1939.

Warnod, André. *Ceux de la Butte*. Paris, 1947.

Warnod, Jeanine. *Suzanne Valadon*. Bergamo, Italy, 1981.

Weill, Berthe. *Pan dans l'œil (1900–1930)*. Paris, 1933.

Werner, Alfred. "The Unknown Valadon." In *Arts Magazine*. Vol. 30, No. 8. May 1956, pp. 169–177.

Yaki, Paul. *Le Montmartre de nos vingt ans*. Paris, 1981.

PRINCIPAL CATALOGUES

Musée National d'Art Moderne. *Suzanne Valadon*. Jean Cassou, Paris, 1948.

Haus des Kunst. *Suzanne Valadon*. Munich, 1960.

Musée de l'Ain. *Periode de St. Bernard: Utrillo, Valadon, Utter*. Catalogue by Francoise Baudson, 1965.

Musée National d'Art Moderne. *Suzanne Valadon*. Catalogue by Pierre Georgel. Preface by Bernard Dorival. Notes by Robert Le Masle. Paris, 1967.

Maisons des Arts et des Loisirs. *Suzanne Valadon*. Preface by Pierre Georgel, Sochaux. 1976.

Musée Toulouse-Lautrec. *Maurice Utrillo, Suzanne Valadon*. Catalogue by Michel Cassel, Jean de Voisin, Jean-Alain Meric. Albi, 1979.

INDEX